creative
FOUNDATIONS

40 Scrapbooking and Mixed-Media Techniques to Build Your Artistic Toolbox

VICKI BOUTIN

NORTH LIGHT BOOKS
Cincinnati, Ohio

CreateMixedMedia.com

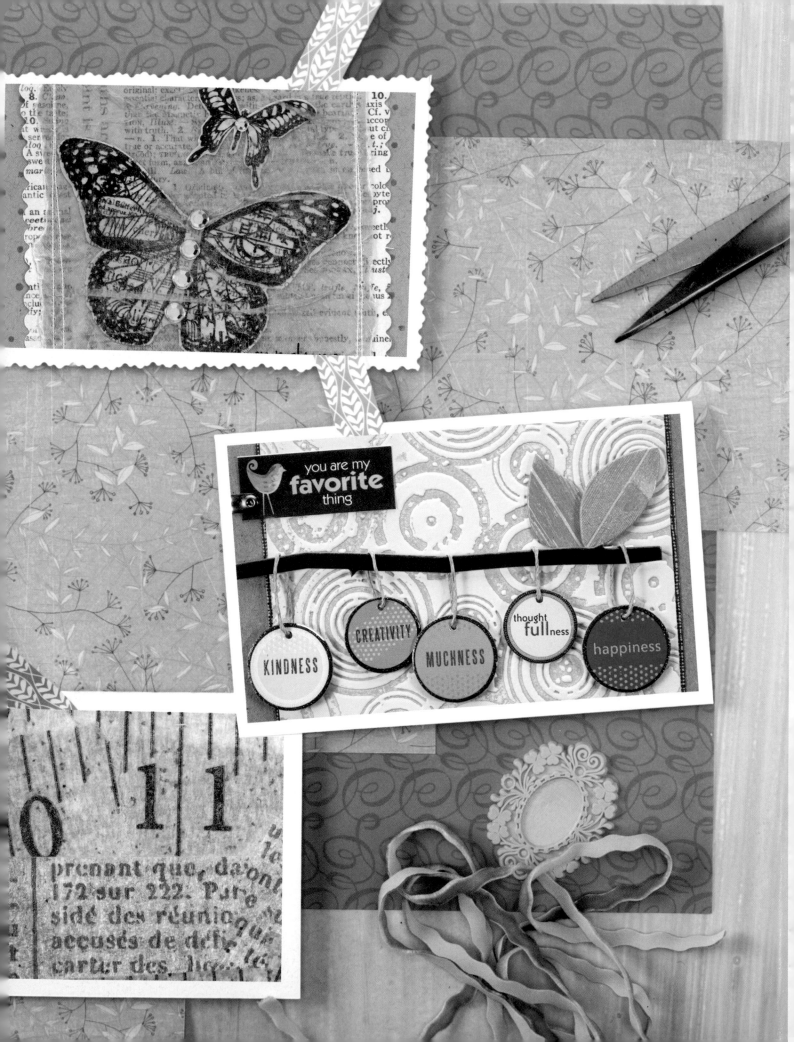

creative
FOUNDATIONS

40 Scrapbooking and Mixed-Media Techniques to Build Your Artistic Toolbox

VICKI BOUTIN

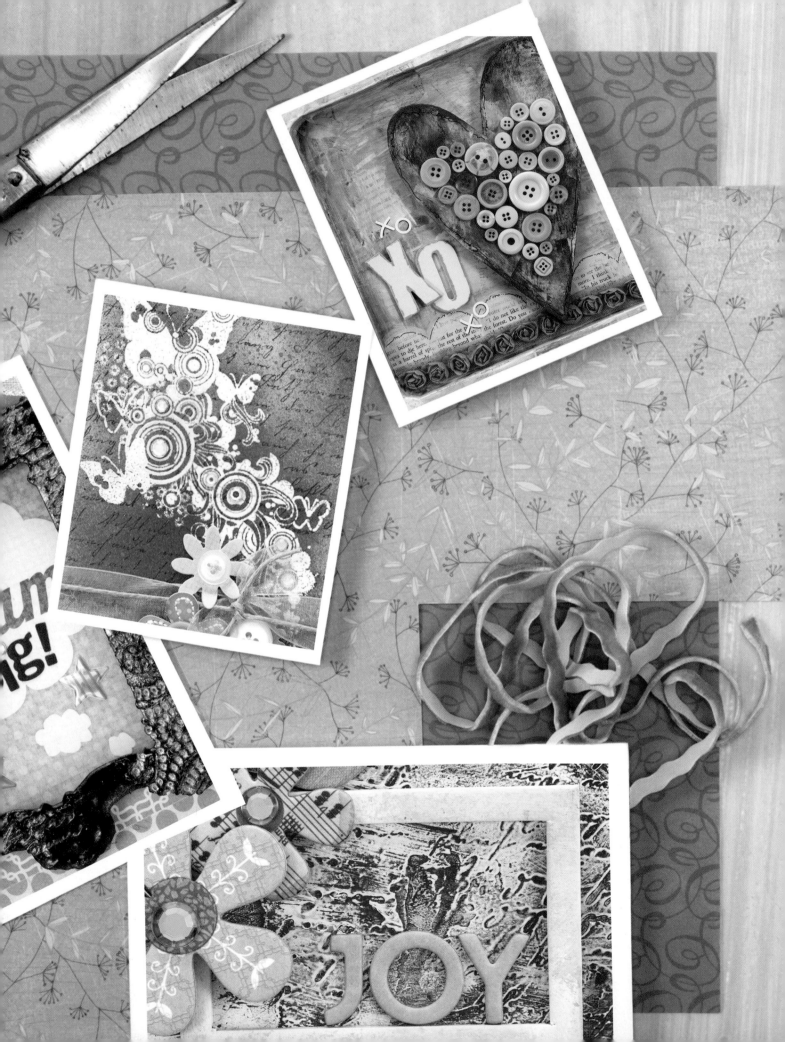

table of
CONTENTS

Every project needs a solid foundation. So roll up your sleeves and prepare to get your hands dirty. You're going to mask, resist and stamp to your heart's desire!

Want to make your projects pop with a little touchy-feely texture? This time around we'll be working with tissue paper, fabric, glitter, gesso and more.

Are you warmed up yet? In this chapter we'll focus on recycling, reducing and reusing ... in ways you never thought possible! So hold on to that old cardboard box, those used dryer sheets and candy wrappers—they're just a few of the unique materials we'll be working with!

It's time for the finishing touch, the pièce de résistance ... the embellishments! We will focus our attention on using beads, playing with pigment powders and making lots of flowers. After all, it's the details that can take a piece from good to great!

The techniques have been categorized and stepped out, and now it's time to pick and choose and merge them together to make pretty art. It's all about the layers!

An eclectic mix of crafters—from scrapbookers to stampers to mixed-media artists—have all adapted the techniques to create singular works of art that reflect their personal style. I hope you'll be inspired to do the same!

introduction
A PLACE TO START

Are you ready to have some fun and get your hands dirty? As you peruse the pages of this book, I want you to be enveloped in color, tickled with whimsy and, most of all, excited to get started! There are no limits here. This book is filled with lots of ideas and what I like to call creative jump starts. The only thing expected of you is that you give it a try!

An everyday art maker—that is what I strive to be. I try not to label my "style" or box myself into using only one medium. Scrapbooking, card making, stamping, textile art and mixed media . . . I explore them all and weave them together! My intention is to create for the simple enjoyment of it and not to put limits on that. Take the ideas I have outlined and make them your own. Design styles change and evolve, and the way that happens is through the exploration of new things and the adaptation of old things.

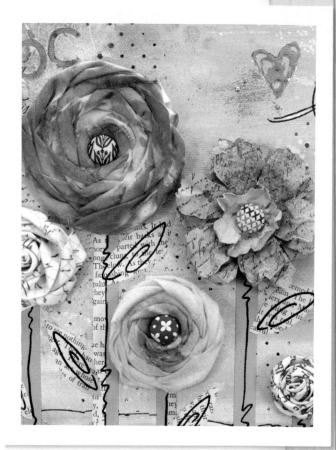

Creative Foundations is about breaking down the details and looking at them as layers. This is the way I approach most things. Start with a good foundation or background, then add a little visual interest with texture, supplement that with a fun twist and, finally, embellish or accessorize. To be honest, I think this is the same way I tackle decorating my home and myself! I like to start at the beginning and build up from there. I have found this strategy to be very helpful in my workshops, and I think it will provide you with a strong plan of action.

The projects in this book range from simple to multifaceted. Don't be afraid to try anything. It's okay to make mistakes (or what I refer to as happy accidents). This is how we learn, grow and improve as creative beings. You may not get it right the first time, but don't give up. You didn't get on a bicycle and ride it down the road the first time. All good things come with practice. On a high note, some of my favorite pieces have come from what was first thought to be an "oops!"

So throw on your apron, gather up your stuff and grab lots of scraps to practice on. Don't be too hard on yourself, and have fun! I am here to guide you through it, and I know you are going to love these techniques as much as I do!

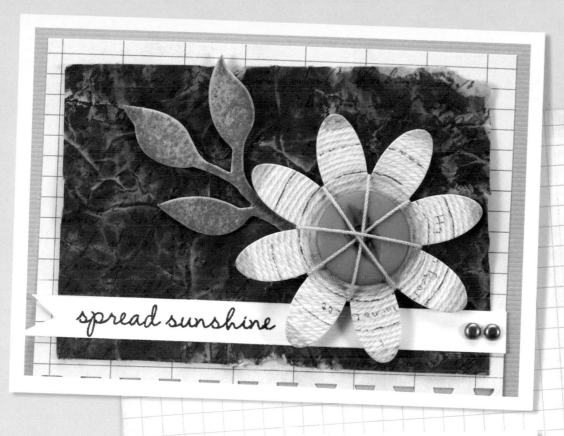

spread sunshine

You kids make the most of your time together!

5
6
7
8
9
0

13
3
4
5

always
enjoy today

chapter one
FOUNDATIONS

Every good project needs a sound foundation. From a creative perspective, we might refer to this as the background. This is where a lot of experimenting will come into play, and it's a perfect place to begin.

In this chapter, we will explore different uses for inks, paints, art medium, stamps and more. When I am working on a background for a project, I like to start with a clean and covered work space. Make sure you have paper towels and baby wipes handy for a quick cleanup. This really is a practice session, so be prepared to play! Add layers and take them away, try different color combos, change your paint consistencies and test different products. These are all suggestions to help further your success.

So get ready to mask, resist and stamp to your heart's content! You are going to get dirty and have fun doing it. Got it? Now go! Like I tell my kids, you won't know if you like it unless you try it! And try it twice for good measure.

BUBBLE WRAP

Who would have thought bubble wrap could be so much more than an instrument of sound created to annoy parents everywhere? This is a readily available material that can be used in several ways to create a base or background. The repetitive nature of the circles is a design marvel. I like to use bubble wrap both to create an entire background, as seen in this example, as well as to add small sections of visual interest.

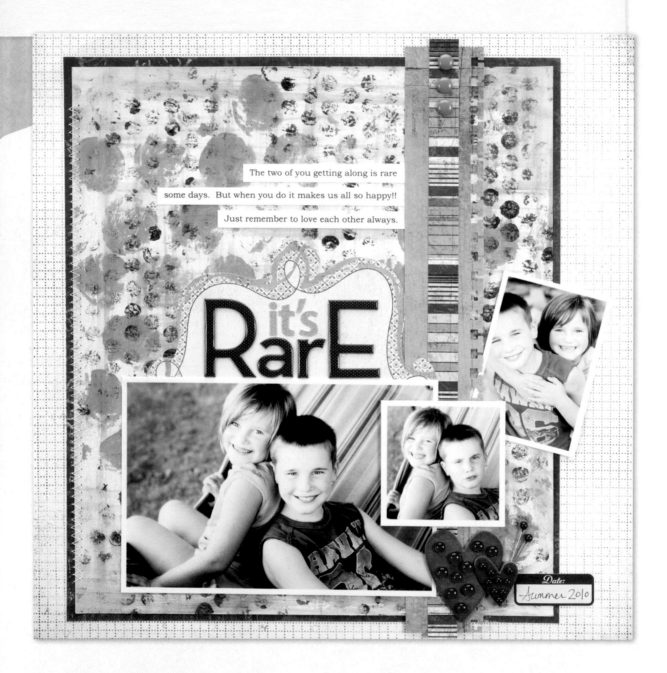

IT'S RARE LAYOUT MATERIALS LIST

adhesive (*Scrapbook Adhesive by 3L*) • bubble letters (*Making Memories*) • bubble wrap • brads (*BasicGrey*) • cardstock (*Bazzill Basics*) • gems (*Stamping Bella*) • ink (*Ranger Industries*) • paint (*DecoArt*) • paper punch (*EK Success*) • patterned paper (*BasicGrey*) • stickers (*Doodlebug Design, October Afternoon*)

WHAT YOU'LL NEED

Acrylic paint

Nonstick craft mat

Brayer

Bubble wrap (small and large circles)

Cardstock

Spray ink (water-based)

Baby wipes, paper towels or foam brush

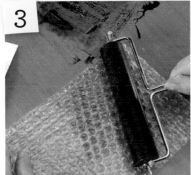
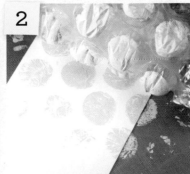
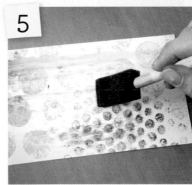
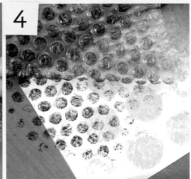

1. Spread acrylic paint on a nonstick craft mat. Roll a brayer through the paint until it is evenly covered. Brayer a thin layer of paint over a piece of bubble wrap (the kind with large bubbles).

2. Turn the paint-covered bubble wrap over and place it on a sheet of cardstock. Rub your hand over the back of the bubble wrap to transfer the paint. Lift off the wrap. Repeat until the desired pattern is achieved. Allow the paint to dry completely.

3. Spritz a small amount of spray ink on a nonstick craft mat. Roll a brayer through the ink until it is evenly covered. Brayer a thin layer of ink over a piece of bubble wrap (this time, the kind with small bubbles).

4. Turn the ink-covered bubble wrap over and place it on a sheet of cardstock. Rub your hand over the back of the bubble wrap to transfer the ink. Lift off the wrap. Repeat until the desired pattern is achieved. Allow the ink to dry completely.

5. To create a watercolor effect, drag a damp paper towel, baby wipe or foam brush over the inked dots to drag the ink. The water-based ink should move around the page, creating a striated pattern.

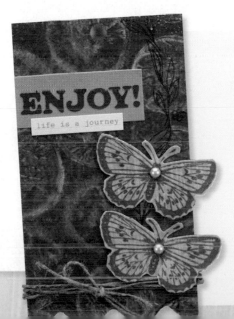

A Little Something Extra:
REVERSE BUBBLE WRAP TECHNIQUE

Instead of applying paint with bubble wrap, try removing paint with bubble wrap! Add a layer of paint to your project's surface. Then immediately press clean, dry bubble wrap into the paint and then remove the bubble wrap quickly. You'll be left with the subtle impression of the bubble wrap's circles.

ENJOY TAG REVERSE BUBBLE WRAP MATERIALS LIST

ink (Ranger Industries) • paint (Ranger Industries) • patterned paper (BasicGrey) • pearls (Queen & Co.) • stamps (Hero Arts, Fiskars) • stickers (Little Yellow Bicycle, Studio Calico) • tag (Kaisercraft) • bubble wrap • twine

CRAYON RESIST

I would like to thank my kindergarten teacher for introducing me to the wonders of crayon resist. I often incorporate this technique on its own with a little freehand drawing, and sometimes I use it to enhance a stamped pattern. This technique works especially well on lighter colored bases. And I'll bet you have tons of crayons lying around—just make sure you snag the white ones!

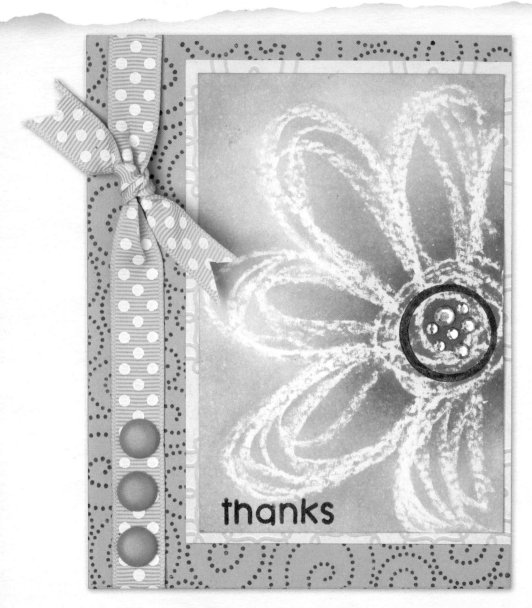

THANKS CARD MATERIALS LIST

adhesive (*Scrapbook Adhesives by 3L*) • brads (*Doodlebug Design*) • cardstock (*Michaels*) • crayon (*Crayola*) • inks (*Ranger Industries*) • patterned paper (*Sassafras*) • rhinestones (*Queen & Co.*) • ribbon • stamps (*Hero Arts, Gel-à-tins*)

WHAT YOU'LL NEED

White crayon

Cardstock

Foam sponge or blending tool

Distress Ink or dye-based ink pads

Baby wipes or paper towels

Details, Details

- My go-to ink for techniques and to add color is Ranger's Distress Ink. This product is totally unique. It is water soluable, it has a longer drying time and it really moves on paper and chipboard.

- All of these qualities plus so many others make Distress Ink one of a kind. Feel free to try out other inks too, but know that Distress Ink will work with all of the techniques in this book.

- Using a foam sponge allows you to get into tight corners and work greater details than other blending tools.

 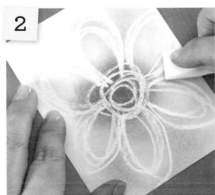 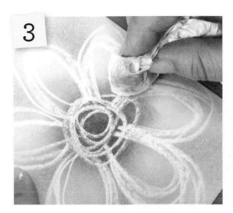

1 Using a white crayon, draw a design or image on a piece of cardstock.

2 Using a foam sponge or blending tool, ink the entire piece of cardstock. Here I used three colors of ink.

3 With a baby wipe or damp paper towel, buff the ink off the wax image.

ex · plore

A Little Something Extra:
COLORED CRAYON RESIST

Using a colored crayon (especially one with a little glitter in it) will yield a really cool effect. In the tag on the left, I used a green glitter crayon instead of the standard white crayon. Why don't you spend a bit of time exploring the possibilities for crayon resists?

EXPLORE TAG MATERIALS LIST

adhesive (*Scrapbook Adhesive by 3L*) • buttons • chipboard (*Kaisercraft*) • crayon (*Crayola*) • ink (*Ranger Industries*) • patterned paper (*BasicGrey, Kaisercraft*) • stamp (*Hero Arts*) • stickers (*Sassafras*) • staples • tag (*Hampton Art*)

GEL MEDIUM RESIST

Gel medium works as a great resist. For this example, I used Claudine Hellmuth Studio Multi-Medium and foam stamps to create the design, but the medium can be applied in any number of ways. The effect is similar to the look of clear embossing powder and stamps. This resist technique works really well when a clear layer is desired.

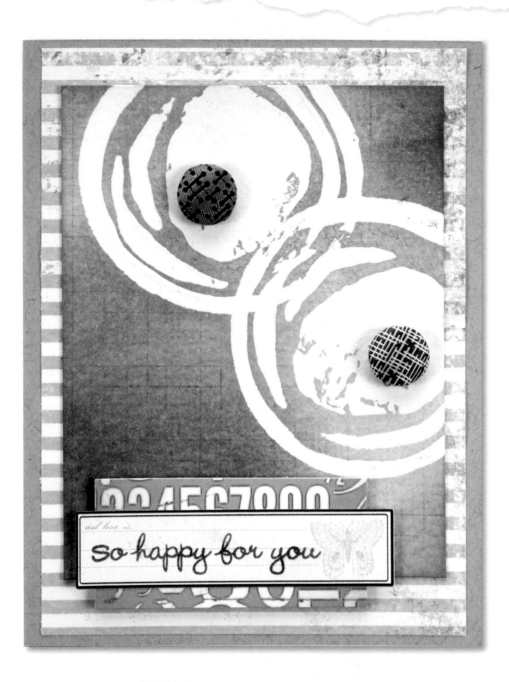

SO HAPPY FOR YOU CARD MATERIALS LIST

adhesive *(Scrapbook Adhesive by 3L)* • blending tool *(Ranger Industries)* • brads *(Sassafras)* • card *(Hero Arts)* • cardstock *(Bazzill Basics)* • gel medium *(Ranger Industries)* • inks *(Ranger Industries)* • numbers *(Webster's Pages)* • patterned paper *(7gypsies)* • stamps *(Hero Arts; Ranger Industries)* • tags *(Studio Calico)*

WHAT YOU'LL NEED

- Foam brush
- Artist-quality acrylic gel medium (matte)
- Foam stamp
- Cardstock
- Nonstick craft mat
- Distress Ink or dye-based ink pad
- Foam sponge or blending tool
- Baby wipes
- Paper towels
- Background stamp

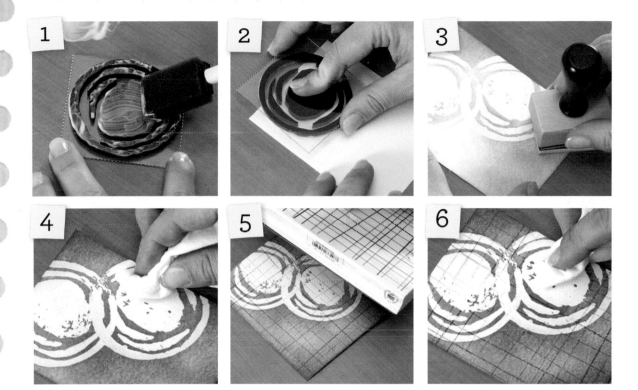

1 Using a foam brush, apply a moderately thick layer of gel medium to a foam stamp. Do not coat the foam stamp with too much medium, or the image may become distorted.

2 Stamp the image on a piece of cardstock. Repeat until the desired design is achieved. Allow the gel medium to dry completely.

3 Apply ink to the entire piece of cardstock with an ink blending tool or a foam sponge.

4 Using a damp paper towel or a baby wipe, lightly wipe the stamped images to remove excess ink. The gel medium will resist the ink.

5 Buff the stamped area with a dry paper towel. Ink a background stamp and stamp the entire image.

6 Remove any excess ink from the stamped image with a damp paper towel or baby wipe. Buff the stamped area with a dry paper towel.

Details, Details

- Stamps with bold, basic images work best with this technique. Avoid heavily detailed stamps.
- Make sure the towel or wipe you use in Step 4 is not too wet, or it may remove the ink from the cardstock.

MAGAZINE COLLAGE

When I flip through magazines, I love to collect images and ads that catch my eye. This technique allows me to use up my stash. The colorful scraps can act as the perfect camouflage if my base is less than perfect, and it almost acts like a bandage. I also love how the type and images "peek" through the paint.

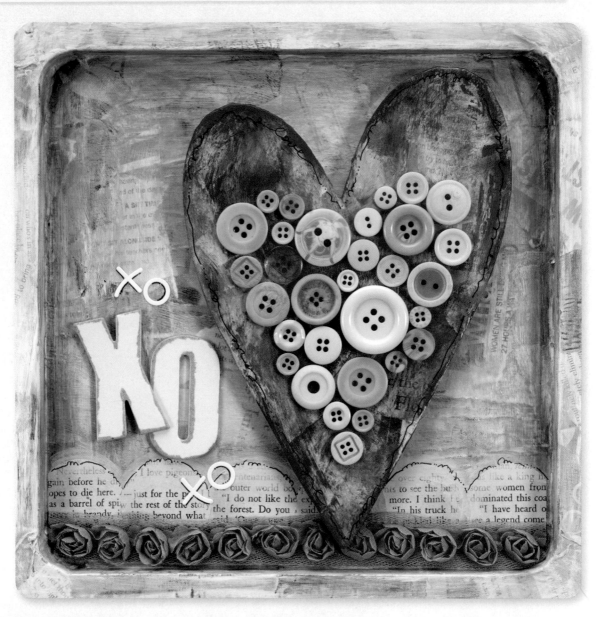

XO XO TRAY MATERIALS LIST

adhesive (*Scrapbook Adhesives by 3L*) • blending tool (*Ranger Industries*) • book paper • buttons • chipboard *heart* (*7gypsies*) • chipboard letters (*Pink Paislee*) • gel medium (*Ranger Industries*) • gesso (*DecoArt*) • paint (*DecoArt*) • paper punch (*EK Success*) • pen (*Sakura*) • rose trim • stickers (*Doodlebug Design*) • tray (*Don Mechanic Enterprises*)

WHAT YOU'LL NEED

Magazine page scraps

Foam brushes

Artist-quality acrylic gel medium (matte)

Cardstock or chipboard

Gesso

Water

Acrylic paints

Baby wipes or paper towels

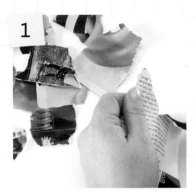
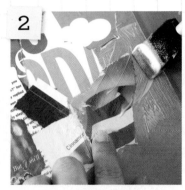
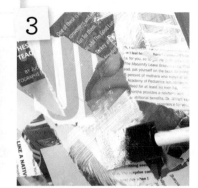
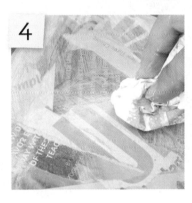
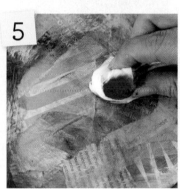

1 Tear magazine page scraps into small pieces and strips. Glossy pages work best.

2 Brush gel medium on the background piece, layer the torn pieces of magazine on the cardstock or chipboard and coat with another layer of art medium. Continue until the entire piece is covered. Allow the piece to dry completely.

3 Brush the gesso sparingly over the collaged magazine pieces, but do not cover the entire surface with the gesso mixture. If the gesso is too thick, you can mix it with water to make it thinner

and more translucent. Why? Some gesso is very thin out of the container while others are thick. Allow the piece to dry completely.

4 Apply a light shade of acrylic paint, diluted with water, to the entire surface. Allow the paint to dry slightly, and then buff some of the color off with a damp paper towel or baby wipe.

5 Apply a second, darker color, allow it to dry slightly and buff, as in Step 4. Continue to build the paint layers until the desired effect is achieved.

Details, Details

• Work in small sections to ensure that the gel medium doesn't dry too quickly.

• To add depth or shadows to dimensional pieces, rub or brush on a small amount of black paint or ink around edges or in crevices, and buff off with a damp paper towel or baby wipe.

• Make sure that each time you buff, you use a clean paper towel— you don't want to transfer paint from the towel to your piece!

MASKED BACKGROUND

Think of mountains, clouds or even an underwater scene: This layered mask technique creates the illusion of depth and airiness. I like to use it on cards as well as layouts. It amazes me what can be done with a piece of paper and some ink.

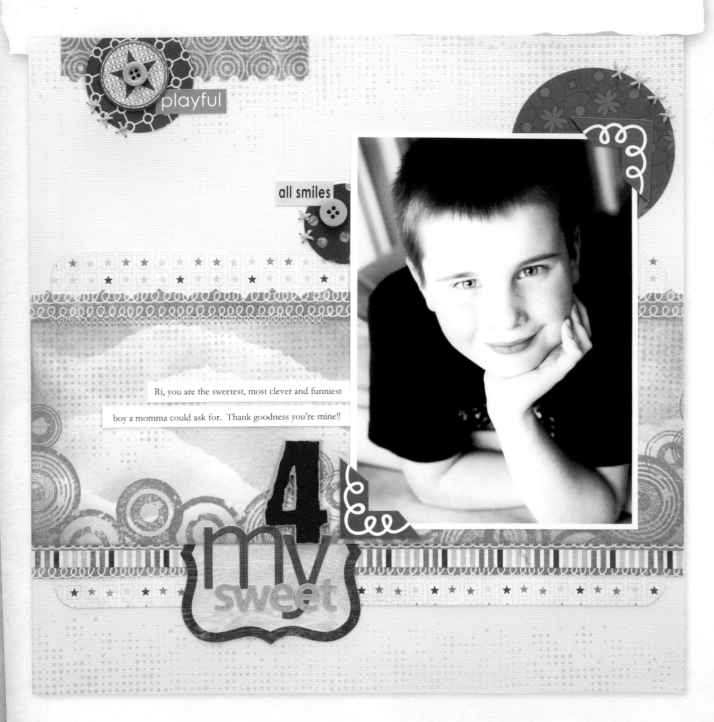

4 MY SWEET LAYOUT MATERIALS LIST

adhesive (*Scrapbook Adhesive by 3L*) • buttons • cardstock (*Core'dinations*) • chipboard number (*Pink Paislee*) • font (*downloaded from the Internet*) • ink (*Ranger Industries*) • paper punches (*Fiskars*) • patterned paper (*My Mind's Eye, Studio Calico*) • stamps (*Stampers Anonymous*) • stickers (*BasicGrey, Sassafras*) • tag (*BasicGrey*) • thread

Cardstock (for base and masks)

Foam sponge or blending tool

Distress Ink or dye-based ink pads

Background stamp

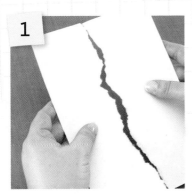

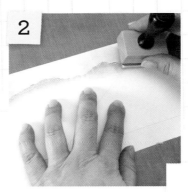

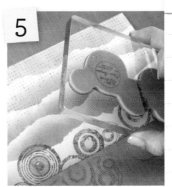

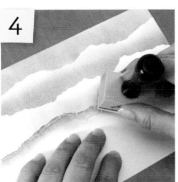

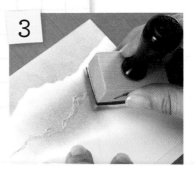

Details, Details

- With this technique I used Ranger's Distress Ink (see Details, Details, page 13) and Ink Blending Tool. The tool allows you to control the amount of ink that you add to the paper. I love that the Ink Blending Tool allows me to add a light layer or a heavier layer of ink.

1 Tear a piece of cardstock into two pieces lengthwise. These pieces are the "masks."

2 Place one mask on a piece of cardstock and apply the first color of ink using a foam sponge or blending tool.

3 Place the other half of the torn strip of cardstock slightly below where the first strip was, and apply the second color of ink.

4 Repeat Steps 2 and 3 until the cardstock is covered with as much ink as your project requires.

5 Ink one or more background stamps and stamp the cardstock with coordinating ink colors to tie the image together.

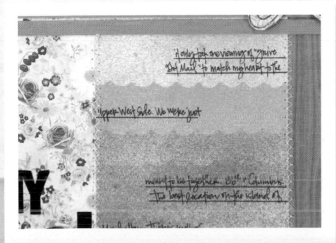

A Little Something Extra:
BORDER PUNCH MASK

For a twist on this technique, use border punches to create your mask, like Kelly Purkey did on her layout, This Is My Street. (Kelly's full layout can be seen on page 127.)

MONOPRINT

Monoprinting is a type of printmaking in which only one image can be created at a time. In this example, I transferred my image using acrylic paint because it is readily available, but printing inks can also be used. The result has a very painterly effect and creates interesting, one-of-a-kind backgrounds.

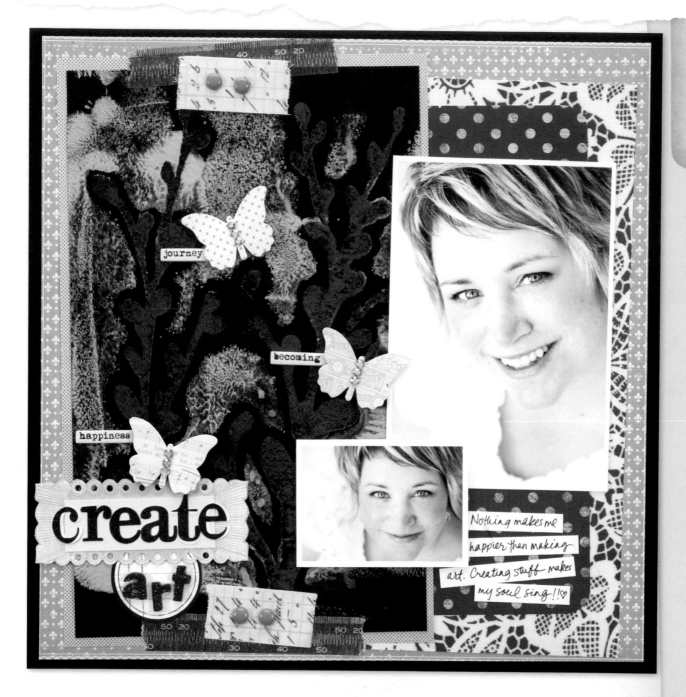

CREATE ART LAYOUT MATERIALS LIST

adhesive (*Scrapbook Adhesives by 3L*) • acrylic sheet • cardstock (*Core'dinations*) • chipboard words (*GCD Studios*) • die cuts (*K&Company*) • tape (*7gypsies*) • butterfly embellishments (*Jenni Bowlin*) • brads (*Doodlebug Design*) • die-cutting machine (*Silhouette*) • paint (*Ranger Industries, DecoArt*) • paper punch (*Fiskars*) • patterned paper (*Fancy Pants, Jenni Bowlin, Little Yellow Bicycle, October Afternoon*) • pen (*American Crafts*) • stickers (*BasicGrey, Creative Imaginations, Webster's Pages*)

WHAT YOU'LL NEED

Brayer
Acrylic paint
Plexiglas
Water mister

Cardstock shapes
Cardstock
Water
Baby wipes or paper towels

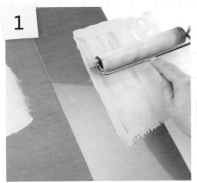
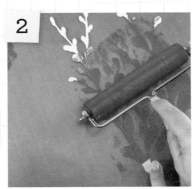
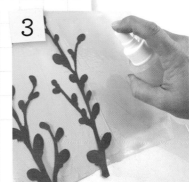

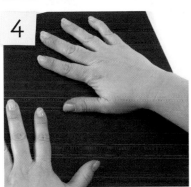
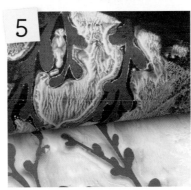

1 Brayer a thin layer of acrylic paint onto a sheet of Plexiglas and mist with water.

2 With a brayer, add a different color of acrylic paint to die-cut shapes, and mist with water.

3 Add the shapes on top of the paint-covered sheet of Plexiglas and lightly mist the entire area with water.

4 Immediately place a sheet of cardstock over the Plexiglas sheet and rub your hand over the back of the paper to transfer the image.

5 Carefully lift the cardstock off the Plexiglas sheet. Allow the cardstock to dry completely.

Details, Details

- Try using printing ink rather than acrylics to stretch out working time. Also try a paint extender rather than water to increase the open time.

- Do not overmist or the paint or ink will run and the detail will be lost.

- This one can take a little practice—don't give up! The end result is worth the effort!

- Die-cutting machines are a great source for creating paper shapes.

NEGATIVE MASK

I own and use a number of die-cutting machines. Once I use the shape I've cut out, I am left with a pile of scraps. I like to use these leftover shapes as "negative" masks. This is yet another reason I don't throw anything away; it cuts down on waste, and it saves me time. I love this one!

BE LAYOUT MATERIALS LIST

adhesive (*Scrapbook Adhesives by 3L*) • brads (*Sassafras*) • cardstock (*Bazzill Basics*) • chipboard letters (*American Crafts*) • die-cut shapes (*Silhouette*) • inks (*Ranger Industries*) • markers (*Copic*) • mica powder (*Ranger Industries*) • medium pen (*Ranger Industries*) • patterned paper (*Little Yellow Bicycle*) • ribbon • stamps (*Hero Arts, Stampers Anonymous*) • stickers (*Cosmo Cricket, Little Yellow Bicycle, Studio Calico*)

WHAT YOU'LL NEED:

Cardstock

Foam sponge or blending tool

Distress Ink or dye-based ink pads

Stamps

Heat gun

White pigment ink pad

Permanent or archival-quality black ink pad

Black pen

White gel pen

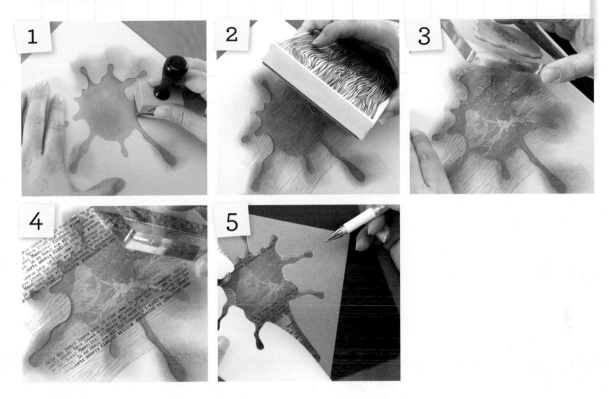

1. Cut a mask from a sheet of cardstock. Place the reverse mask (cardstock minus the cutout) over a piece of cardstock, and use a foam sponge or blending tool to add two shades of ink inside the circle. (Ranger's Ink Blending Tool works wonders here! See Details, Details, page 19 for more information.)

2. Ink a background stamp with a darker shade of ink and stamp inside the mask. Dry the stamped area with a heat gun. (Do not overheat.)

3. Ink a stamp with white pigment ink and stamp inside the mask.

4. Ink a stamp with permanent black ink and stamp another layer or two inside the mask. Heat set the inks with a heat gun.

5. Trace the outline of the mask with a fine-tipped black marker or pen. Trace around the outline with a white gel pen.

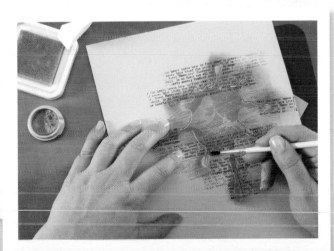

A Little Something Extra:
ADD A BIT OF SPARKLE

With the mask still in place, draw around the outer edge with a Perfect Medium Pen. Then, using a paintbrush, add Perfect Pearls Pigment powder while the medium is still wet. Brush off any excess Perfect Pearls with a clean, dry brush after the ink has dried. (See page 57 for more information about Perfect Pearls.)

REVERSE RESIST

Watercolor is one of my favorite art mediums. It is fluid and forgiving. This wet-on-wet technique is easy to achieve, and it has a very ethereal look. Just imagine the possibilities!

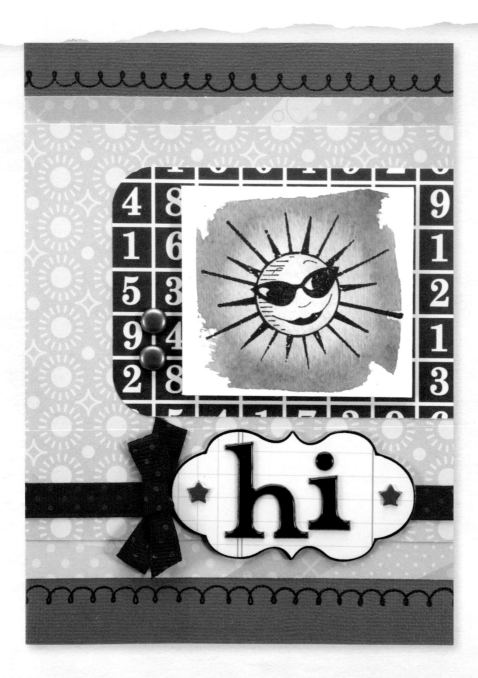

HI CARD MATERIALS LIST

adhesive (*Scrapbook Adhesives by 3L, Stix2–kool tak*) • brads (*7gypsies*) • cardstock (*Core'dinations*) • chipboard (*Pink Paislee*) • ink (*Ranger Industries*) • letters (*American Crafts*) • patterned paper (*Pink Paislee*) • stamps (*Inkadinkado, Sandylion*) • watercolor paint (*Winsor & Newton*)

WHAT YOU'LL NEED

Stamp

Permanent or archival-quality black ink pad

Watercolor paper

Foam brush

Watercolor paint

Paintbrushes

Water

Paper towels

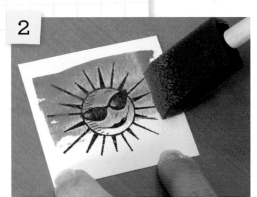

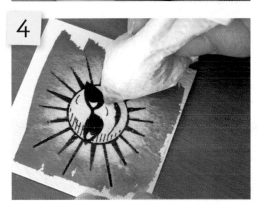

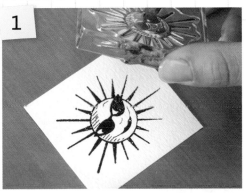

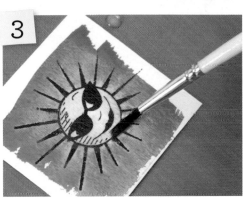

1 Stamp an image on watercolor paper with permanent black ink.

2 Paint a wet layer of watercolor paint across the stamped image.

3 While the paint is still somewhat wet, use a paintbrush dipped in clean water and paint around the image to remove the watercolor paint.

4 Blot off excess water and paint with a dry paper towel.

Details, Details

Make sure to clean your brush often while working through Step 3—the idea is to remove the paint rather than just move it around.

SMOOSHING

This technique is a throwback to my decorative painting days. My first apartment was covered in "smooshed" walls! Now smooshing has seen a rebirth, albeit on a smaller scale. This is one of the simplest background techniques, and it brings one of the biggest wow factors.

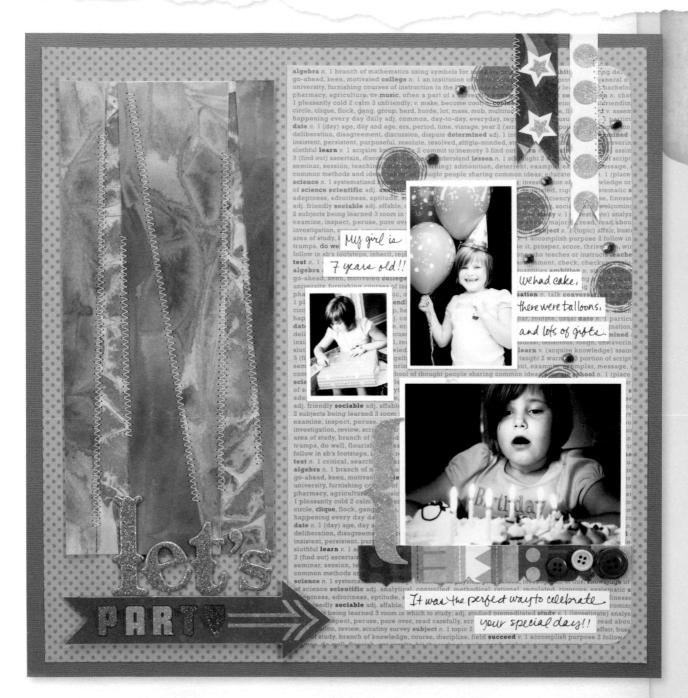

LET'S PARTY LAYOUT MATERIALS LIST

adhesive (Scrapbook Adhesives by 3L) • buttons (Foofala) • cardstock (Core'dinations) • chipboard letters (Pink Paislee) • die cuts (We R Memory Keepers) • patterned paper (Doodlebug Design, Bella BLVD, We R Memory Keepers) • pen (Sakura) • plastic wrap • rhinestones (Queen & Co.) • spray ink (Ranger Industries, Tattered Angels) • stamps (Hero Arts) • thread

WHAT YOU'LL NEED

- Acrylic paint or spray ink
- Water
- Foam brush
- Heavy-weight paper
- Plastic wrap

 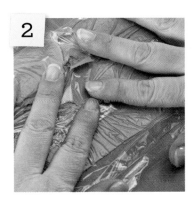

1 Slightly dilute acrylic paint with water and brush it over a piece of heavy-weight paper. After you have applied the paint mix, the paper surface should be very wet, so the paint or ink will be fluid.

2 Immediately cover the paper with a piece of plastic wrap, creating folds and creases. Allow the paint or ink to dry. (Drying time will depend on a few factors, like whether paint or ink is used, the amount of water used in diluting the paint or ink and the type of paper used.)

3 When the paint or ink is almost completely dry, remove the plastic wrap.

Details, Details

- This technique can also be re-created using spray inks.
- To increase your "open" time, try a paint extender like Claudine Helmuth Studio Extra Time by Ranger Industries.

A Little Something Extra:
SO MANY OPTIONS

The possibilities for customization in smooshing are endless. For example, the two samples on the left are background inked with Distress Ink and then misted with Perfect Pearls Pigment powder mixed with water. The two on the right are misted with Glimmer Mist, a spray ink that contains mica powder. Feel free to experiment; what new favorite will you discover?

WAX PAPER RESIST

The crumpled-paper look has always appealed to me, but I'm not actually a fan of crumpled paper. I found a way to get past this hurdle with a little bit of wax paper and an iron. You're going to love watching the pattern come to life once you add the color. Just be careful with the hot iron!

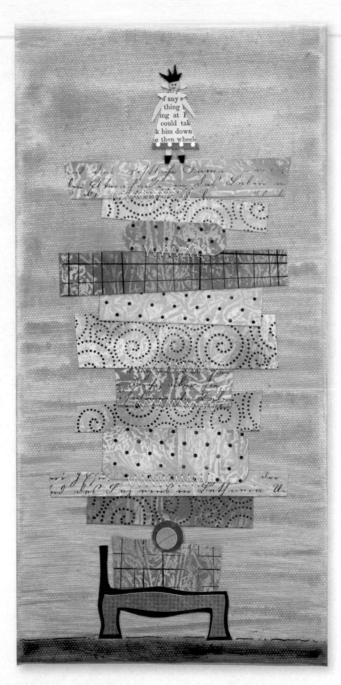

PRINCESS AND THE PEA CANVAS MATERIALS LIST

cardstock *(Prism Papers)* • canvas • gel medium *(Ranger Industries)* • inks *(Ranger Industries)* • patterned paper *(BoBunny Press, Crate Paper, Imaginisce, Pink Paislee)* • stamp *(Hero Arts)* • thread • wax paper

WHAT YOU'LL NEED

Cardstock
Wax paper
Scrap paper
Iron
Foam sponge or blending tool
Distress Ink or dye-based ink pad

Baby wipes or paper towels
Background stamp
Permanent or archival-quality
black ink pad

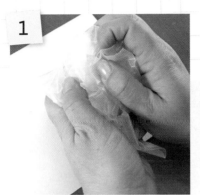
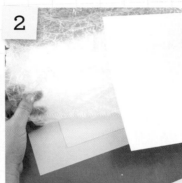
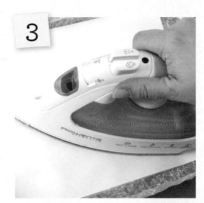
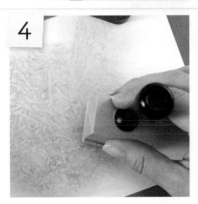
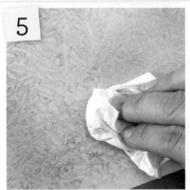
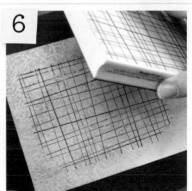

1 Cut a piece of cardstock to size. Crumple a piece of wax paper and lay it over the cardstock.

2 Sandwich the wax paper and cardstock between two sheets of scrap paper.

3 With an iron set on high without steam, iron the sandwiched cardstock and wax paper. Discard the used wax paper and save the scrap paper for another project.

4 Using a foam sponge or blending tool, ink the wax-covered cardstock.

5 Buff the ink off the waxed areas with a damp paper towel or baby wipe.

6 Stamp the cardstock with a background stamp and black ink.

Details, Details

- The paper used to sandwich the cardstock and protect the iron now holds a wax transfer. It can be used in a future project, so don't throw it away!

- Try to stamp the cardstock with a piece of light foam or an old mouse pad beneath it, if possible. The extra "give" will ensure a solid transfer of the stamp image.

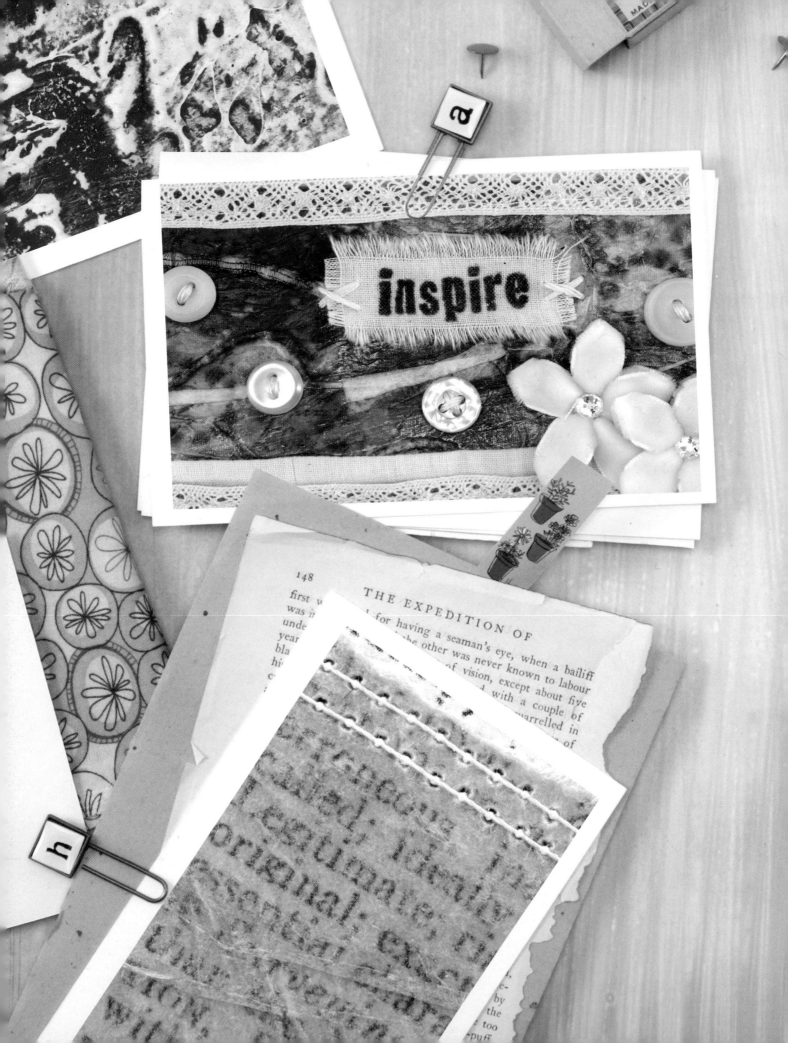

chapter two
TEXTURES

One of the best parts of crafting for me is the tactile aspect of it. I love the hands-on portion. To touch, to feel, to handle, to be immersed in creating: These things make me happiest. So, naturally, I love to add an element of texture to nearly everything I make.

Now that you have played a bit with creating unique backgrounds in Chapter One, let's explore adding depth through texture. Open your mind to using tissue paper, fabric, glitter and more. Some of the techniques in this chapter will show an obvious use of texture, while others are much more subtle. The idea is to create variety and dimension by adding texture.

You'll have a chance to pull out your tissue paper, heat gun and even more stamps. But don't clean up just yet . . . you're still going to be putting your hands in it! As in the previous chapter, the focus is going to be on the individual techniques. Later in the book, I will show you how to layer a few of them. For now, get ready to make your projects pop with a little touchy-feely texture!

EMBOSSED RESIST

Using stamps and embossing powders is a tried-and-true technique! With a clear embossing powder, a "ghost" impression can be created, allowing whatever is on the base to shine through. The texture is smooth and subtle. This resist works especially well with Ranger Distress Inks.

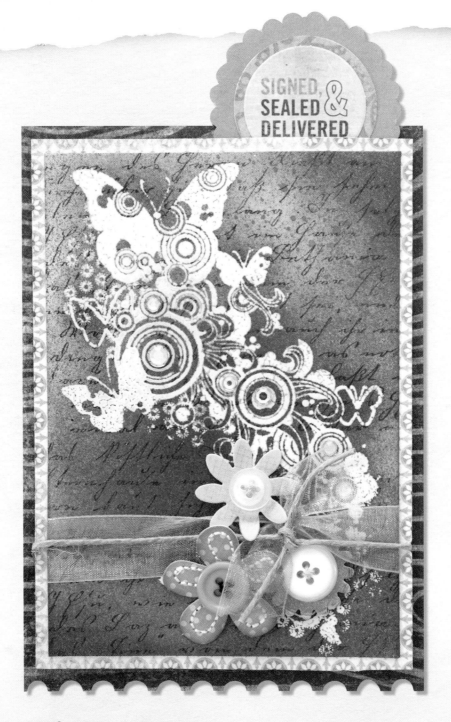

SIGNED, SEALED & DELIVERED TAG MATERIALS LIST

adhesive (Scrapbook Adhesives by 3L) • cardstock (Core'dinations) • die cut (BasicGrey) • embossing powder (Ranger Industries) • flower embellishments (Sassafras) • ink (Ranger Industries) • paper punch (Marvy Uchida) • patterned paper (My Mind's Eye) • rhinestones (Queen & Co.) • ribbon • spray mist (Maya Road) • stamps (Hero Arts, Inkadinkado) • tag (BasicGrey) • twine

WHAT YOU'LL NEED

Stamp

Embossing ink pad

Cardstock

Embossing powder

Heat gun

Distress Ink or dye-based ink pads

Foam sponge or blending tool

Paper towels

Spray ink

Background stamp

Permanent or archival-quality black ink pad

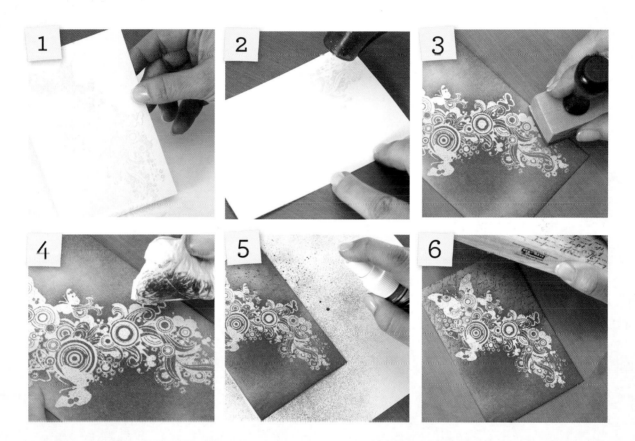

1 Stamp an image with embossing ink on cardstock and immediately sprinkle the stamped area with embossing powder. Tap off the extra embossing powder.

2 Set the embossing powder with a heat gun.

3 Rub ink over the embossed stamp and surrounding area with a foam sponge or blending tool. Here I used three colors of ink.

4 Buff the embossed area with a paper towel. The embossed stamp will resist the ink, allowing the base color to show through.

5 Lightly mist the cardstock with spray ink. Wipe off any excess spray ink.

6 Stamp over the entire area with a background stamp and ink. Wipe off any excess ink.

ENCASED

Tissue paper makes me happy: It comes in a rainbow of colors, is readily available and is inexpensive! What more could a girl ask for? When tissue is covered with gel medium, it becomes transparent and looks almost like onion skin. The art medium also gives the tissue substance and makes it less fragile and less difficult to work with.

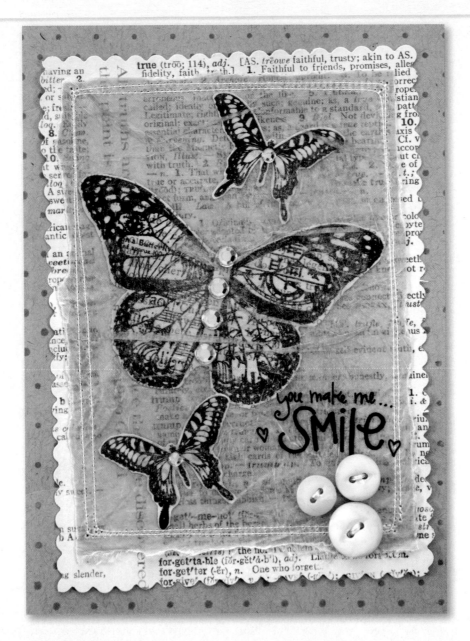

YOU MAKE ME SMILE CARD MATERIALS LIST

adhesive (*Scrapbook Adhesives by 3L*) • buttons • cardstock (*Bazzill Basics*) • decorative scissors (*Fiskars*) • gel medium (*Ranger Industries*) • ink (*Ranger Industries*) • patterned paper (*Making Memories*) • rhinestones (*Queen & Co.*) • rub-ons (*Melissa Frances*) • stamps (*Hero Arts, Pink Paislee, Stampers Anonymous*) • thread • tissue paper

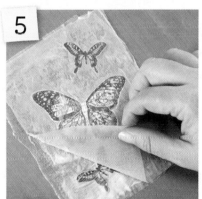

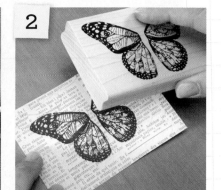

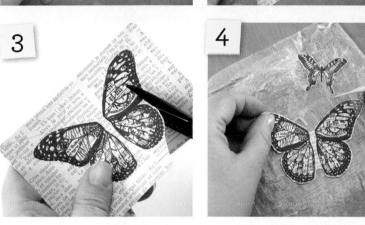

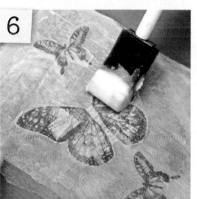

Tissue paper

Nonstick craft mat

Foam brush

Artist-quality acrylic gel medium (matte)

Stamps

Permanent or archival-quality black ink pad

Cardstock

Scissors

1 Place a sheet of tissue paper on top of a nonstick craft mat. Using a foam brush, apply a light coat of gel medium over the tissue paper. Lay a second sheet of tissue paper on top of the first layer and apply a second coat of gel medium. Allow the tissue to dry completely.

2 Stamp images on the cardstock with permanent black ink.

3 Cut out the stamped images.

4 Brush a layer of gel medium over the layered tissue paper with a foam brush and layer the cutouts on top of the tissue paper

5 Brush another layer of gel medium over the tissue and cutouts and add another layer of tissue paper.

6 Seal the top layer of tissue paper with another layer of gel medium. Allow to dry completely.

FABRIC PAINTING

Textile art is an area I am greatly inspired by. I love incorporating fabric into my work, and I often use muslin because it is cheap and cheerful. Muslin has a great texture, it isn't too finicky to work with and it takes paints and dyes really well. The example I used here is very basic; use it as a starting point.

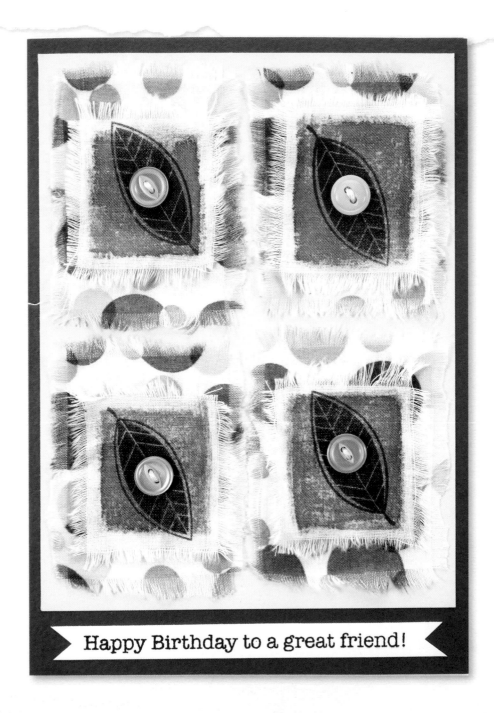

HAPPY BIRTHDAY TO A GREAT FRIEND CARD MATERIALS LIST

adhesive *(Beacon Adhesives)* • buttons • cardstock *(Prism Papers)* • fabric • ink *(Ranger Industries)* • spray ink *(Ranger Industries)* • stamps *(Hero Arts)*

WHAT YOU'LL NEED

- Muslin
- Scissors
- Spray ink
- Nonstick craft mat
- Paintbrush or foam brush
- Permanent or archival quality black ink pad
- Heat gun
- Stamp

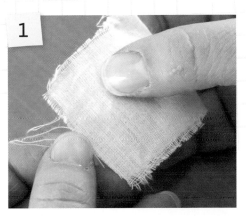

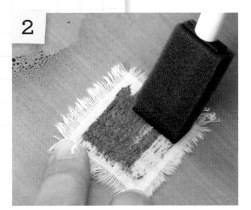

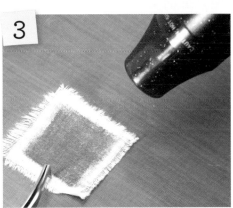

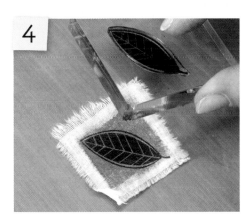

1 Cut the muslin into squares and then fray the edges by pulling out threads.

2 Spray ink onto a nonstick craft mat. Dip a paintbrush or a foam brush in the ink and paint a square in the middle of the muslin pieces.

3 Dry the muslin with a heat gun.

4 Stamp an image in the center of the muslin square with permanent ink.

Details, Details

- Pounce Distress Ink on a nonporous craft mat and add a small amount of water to create a "paintable" ink.
- The ink will spread through the fabric, so use a dry brush and apply the ink in layers to prevent oversaturating the fabric.

FABRIC PAPER

If you have been paying attention, you've probably noticed that I love both tissue paper and textile art. This technique marries the two beautifully! It is so textural and fun. Your finished fabric paper can be quilted, added to cards or it can become wearable art, like this pretty wrist cuff.

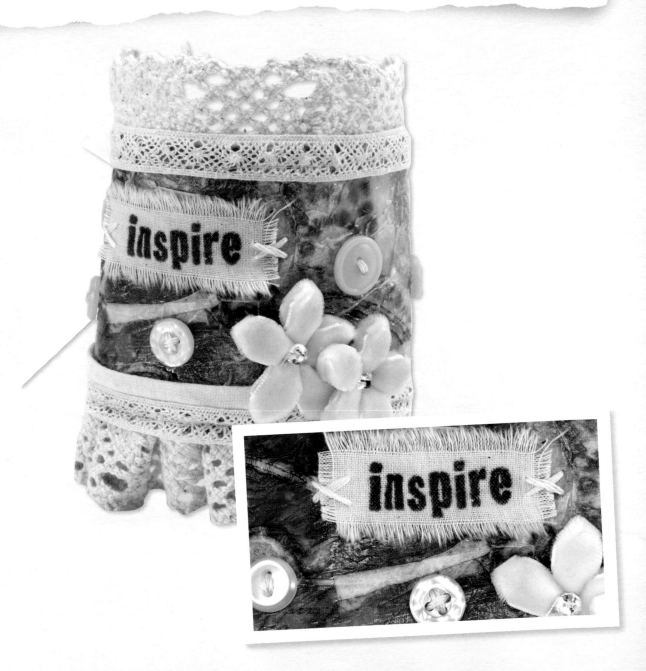

INSPIRE CUFF MATERIALS LIST

adhesive *(Beacon Adhesives)* • buttons • crochet trim • fibers • flower embellishments *(Maya Road)* • gel medium *(Ranger Industries)* • ink *(Ranger Industries)* • muslin • paint *(Golden Artist Colors)* • ribbon *(My Mind's Eye, Stampin' Up!)* • spray mist *(Tattered Angels)* • stamps *(Fiskars, Hero Arts)*

WHAT YOU'LL NEED

Muslin

Scissors

Paper doilies

Spray ink

Nonstick craft mat

Foam brushes and paint brushes

Metallic paint

Background stamp

Permanent or archival-quality black ink pad

Artist-quality acrylic gel medium (matte)

Fibers and other ephemera

Tissue paper

Paper towels

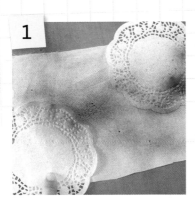 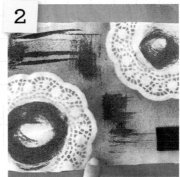 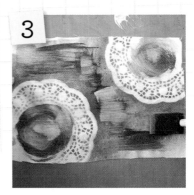

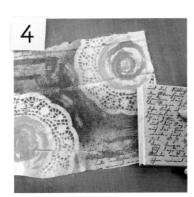 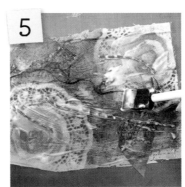 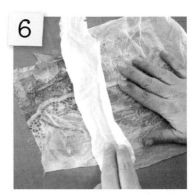

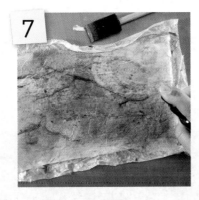

1 Cut a piece of muslin. Using a paper doily as a mask, mist the fabric with spray ink. Allow the fabric to dry completely. (Save used doilies for Step 5.)

2 Spray ink onto a nonstick craft mat and, using a foam brush, brush it on the muslin in a random design.

3 Using a metallic paint, paint on the muslin and then allow it to dry completely.

4 Ink a background stamp with permanent black ink and randomly stamp the muslin. Then, using a foam brush, brush the entire piece with a thick layer of gel medium.

5 Add fibers and torn bits of doilies to the wet gel medium. Brush additional medium over the fibers and doilies.

6 Crumple a piece of tissue paper and layer it over the wet gel medium. Brush a layer of gel medium over the tissue paper. The tissue paper is delicate, so be careful not to tear it. Allow the paper to dry.

7 Drybrush a layer of metallic paint over the tissue. Then lightly mist spray ink over the tissue. Buff off some of the paint and ink with a damp paper towel, if desired.

FAUX LETTERPRESS

Letterpress printing creates a crisp image with deep impressions. This look can be re-created nicely with embossing folders, ink and a die-cutting machine. There are many designs available in embossing folders, and I find it worthwhile to experiment with different inks. Dye inks, for example, give more even and translucent coverage than other inks. For best results, use a brayer to apply the ink to the embossing folder.

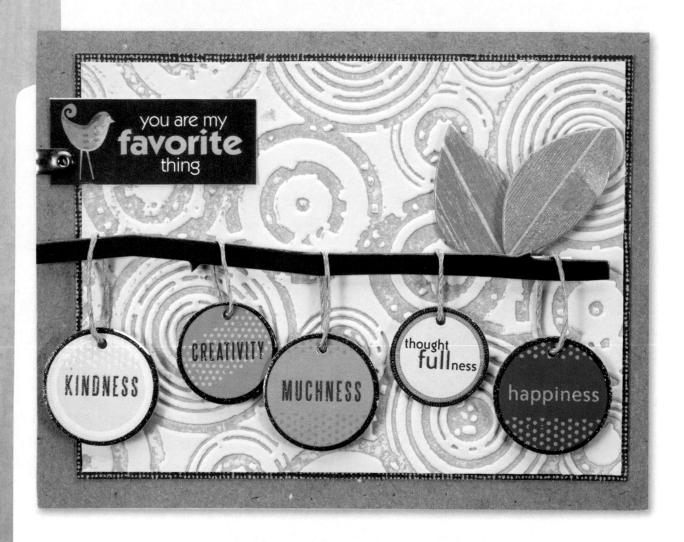

YOU ARE MY FAVORITE THING CARD MATERIALS LIST

adhesive (Scrapbook Adhesives by 3L) • card (Hero Arts) • cardstock (Core'dinations) • chipboard (Little Yellow Bicycle) • die-cutting machine (Sizzix) • embossing plate (Sizzix) • ink (Stampin' Up!) • metal clip (7gypsies) • stickers (Little Yellow Bicycle)

WHAT YOU'LL NEED
Cardstock
Embossing folder
Brayer
Dye-based ink pad
Die-cutting machine

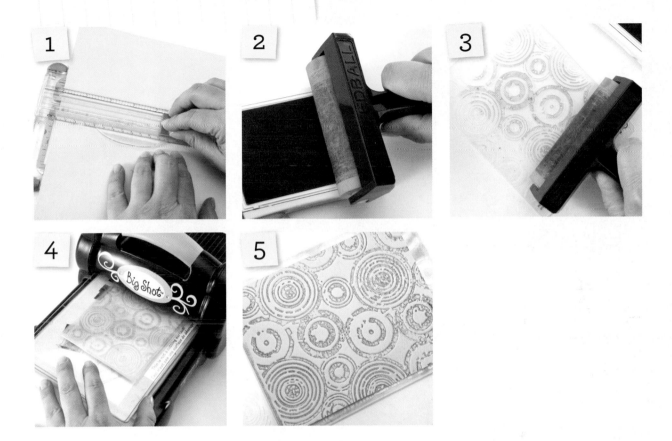

1 Cut a piece of cardstock to fit in the embossing folder.

2 Roll a brayer over an ink pad.

3 Brayer ink evenly over the embossing folder.

4 Carefully sandwich the cardstock inside the embossing folder and slowly run the folder through a die-cutting machine.

5 Remove the inked and embossed cardstock from the folder.

Details, Details
• You may want to experiment with different types of stamping inks to find which ones achieve the coverage you desire. I've found that, for me, the dye-based inks from Stampin' Up! work the best.

FROTTAGE

Frottage is the French word for "rubbing," and I'll bet you learned a form of frottage in elementary school. Didn't you rub the side of a crayon over leaves that had been placed under paper? That's frottage! The technique here is very similar. The texture created is subtle, and the wax works great as a resist.

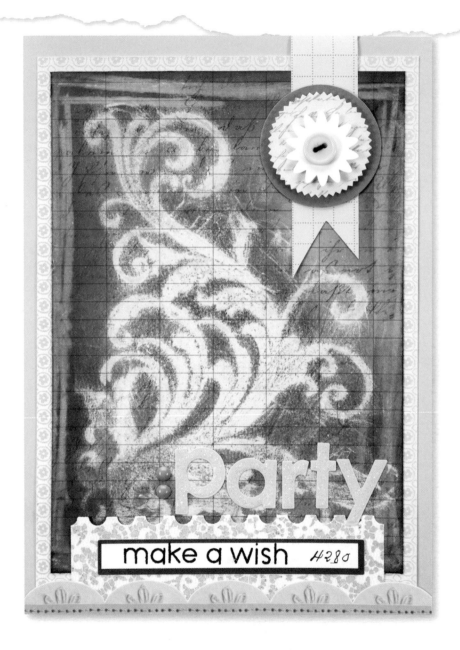

PARTY CARD MATERIALS LIST

adhesive (*Scrapbook Adhesives by 3L*) • border (*Sassafras*) • brads (*BasicGrey*) • cardstock (*Bazzill Basics*) • crayon (*Crayola*) • flower embellishment (*Little Yellow Bicycle*) • ink (*Ranger Industries*) • patterned paper (*BasicGrey, Little Yellow Bicycle, Pink Paislee*) • stickers (*BasicGrey, My Little Shoebox, Sassafras*) • stamp (*Hero Arts*)

WHAT YOU'LL NEED

- Rubber stamp
- Lightweight cardstock
- White wax crayon (label removed)
- Foam sponge or blending tool
- Distress Ink or dye-based ink pads (three shades)
- Paper towels

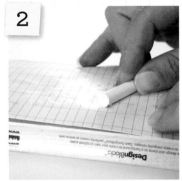

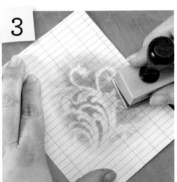

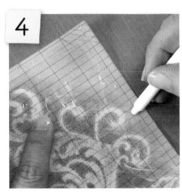

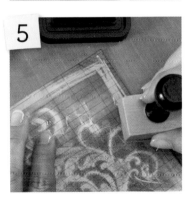

1. Place a rubber stamp with the image facing up and lay a piece of lightweight cardstock on top of it.

2. Hold the cardstock firmly in place and rub the side of a white wax crayon over the entire surface of the rubber stamp until a thick layer of wax is left behind.

3. Using a foam sponge or a blending tool, rub a light shade of ink over the entire image. Rub on a second shade of ink over parts of the image. Then use paper towels to buff off any ink remaining on the waxed areas.

4. Using the white crayon, draw a border around the outer edge of the image.

5. Apply the darkest ink color around the wax frame and then buff off the excess ink with a paper towel.

Details, Details

- A stamp with a bold, heavy design and minimal fine detail will yield the best results.

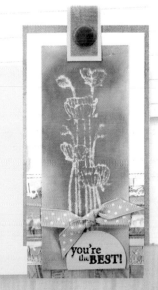

A Little Something Extra:
COLORED CRAYON FROTTAGE

For a slightly different look, try using a colored crayon instead of a white crayon.

YOU'RE THE BEST TAG MATERIALS LIST

brad (Sassafras) • Ink (Ranger Industries) • patterned paper (Sassafras) • stamps (Fiskars; Hero Arts) • ribbon

GESSO

Gesso is usually used as a primer; it's been in my supply case since my art school days. While it works great on canvases, I also love using it to create texture. Interesting patterns can be fashioned by varying the thickness of the gesso and stamping images in it. The best results will be achieved by adding and removing layers of color, thus highlighting the impressions.

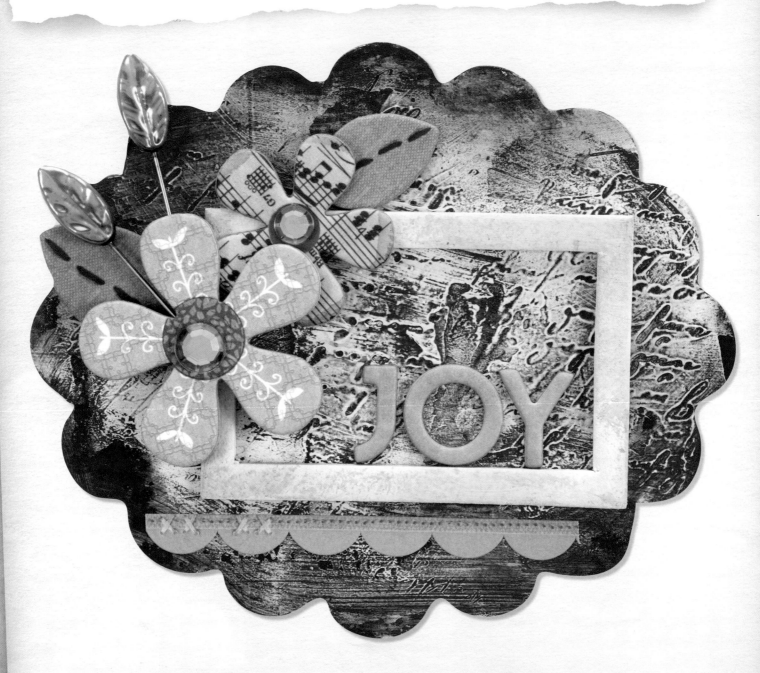

JOY TAG MATERIALS LIST

adhesive (*Scrapbook Adhesives by 3L*) • chipboard (*BasicGrey, Maya Road; Sassafras*) • gesso (*DecoArt*) • ink (*Ranger Industries*) • pins (*Maya Road*) • rhinestones (*Prima Marketing*) • stamps (*Hero Arts*) • stickers (*Sassafras*)

WHAT YOU'LL NEED

Gesso
Chipboard
Plastic card or palette knife
Water mister
Rubber stamp

Distress Ink or dye-based ink pads
Foam sponge or blending tool
Acrylic paint
Paper towels

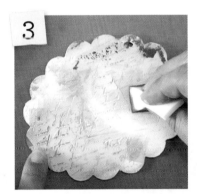

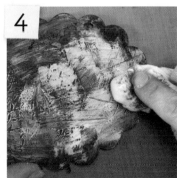

1 Spread a thin, textured layer of gesso over a piece of chipboard with a plastic card or palette knife.

2 Mist a stamp lightly with water and press the stamp into the wet gesso. Repeat until the desired design is achieved. Allow the gesso to dry completely.

3 Apply ink over the gesso using a foam sponge, and then buff off the ink with a paper towel. The goal is to have the ink collect in the depressed areas of the stamp and to remove the ink from the surface.

4 Brush a small amount of acrylic paint over the stamped areas and buff off some of the paint with a paper towel. Allow the paint to dry.

Details, Details

- Be sure to clean your stamp immediately. If the gesso is allowed to dry on the stamp, it'll be really hard to remove it from any fine details.

- Steps 3 and 4 can be repeated as many times as necessary to achieve the look you want.

GLITTER IN WET PAINT

Like any girlie girl, I love glitter! But glitter tends to have a mind of its own, and it can end up *everywhere*. The wet paint in this technique holds the glitter so you don't need to mess around with glue. The areas of paint that have dried prior to the glitter application will, in essence, "resist" the glitter. You can customize the look with any glitter and paint combination.

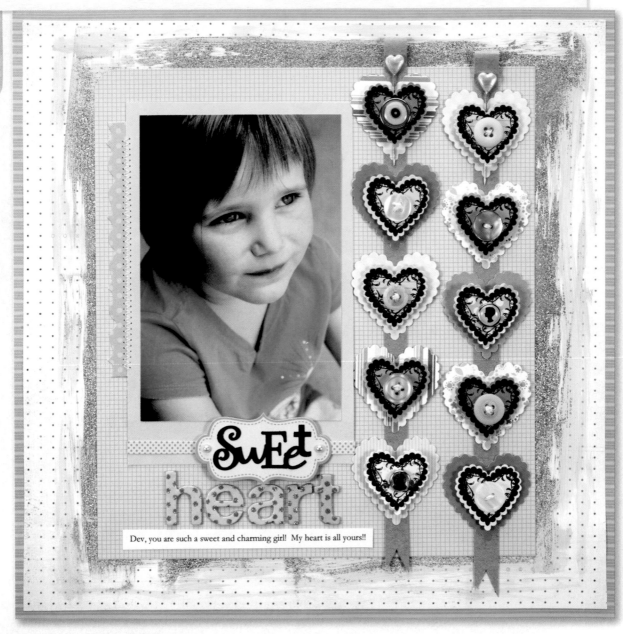

SWEETHEART LAYOUT MATERIALS LIST

adhesive (*Scrapbook Adhesives by 3L*) • buttons • brads (*Sassafras*) • cardstock (*Bazzill Basics*) • chipboard (*American Crafts*) • glitter (*EK Success*) • heart pins (*Maya Road*) • inks (*Ranger Industries*) • label (*October Afternoon*) • paint (*Ranger Industries*) • paper punches (*Fiskars*) • patterned paper (*Three Bugs in a Rug, BasicGrey, Doodlebug Design*) • stamps (*Fiskars*) • stickers (*Making Memories*)

WHAT YOU'LL NEED

Foam brush or wide paintbrush

Acrylic paint

Cardstock

Glitter (fine textured)

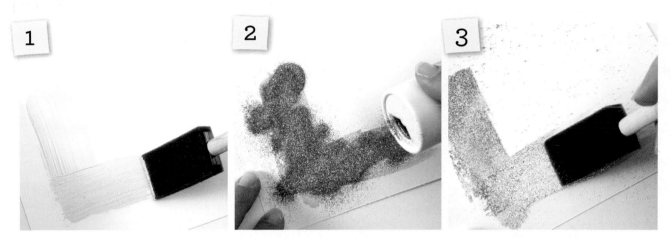

1 Using a foam brush or wide paintbrush, paint a layer of acrylic paint onto cardstock.

2 While the paint is still wet, sprinkle a layer of fine glitter over the paint and set the cardstock aside to dry completely.

3 When the paint is dry, use a foam brush to remove any loose, excess glitter.

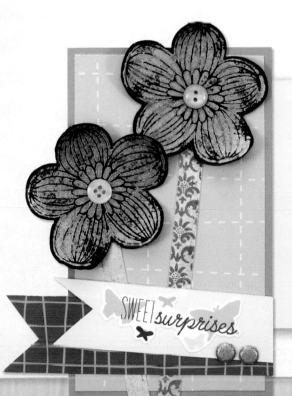

A Little Something Extra:

STAMPED GLITTER IN WET PAINT

Try using paint with your stamps instead of ink, like I did on the card to the left. Then add glitter, as directed in Step 2. This is a "wet" technique—keep in mind that the glitter will only stick where the paint is wet.

SWEET SURPRISES CARD MATERIALS LIST

brads (*American Crafts*) • buttons • card (*American Crafts*) • glitter (*In the Making Enterprises*) • paint (*Ranger Industries*) • patterned paper (*American Crafts, BasicGrey*) • stamps (*Hero Arts*) • sticker (*American Crafts*)

TIE-DYE MARKERS

Here's a technique that requires scrounging through your kids' craft supplies! The color possibilities for this one are limited only by the number of washable markers in your possession. Make sure to add layers of ink and manipulate them with water. I love the leathery look this one creates.

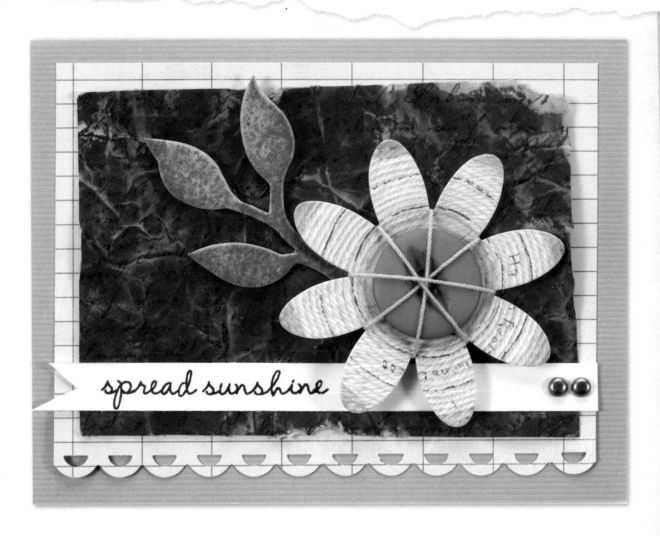

SPREAD SUNSHINE CARD MATERIALS LIST

border punch *(Fiskars)* • brads *(Making Memories)* • cardstock • chipboard leaves and flower *(Sassafras)* • ink *(Ranger Industries)* • patterned paper *(Pink Paislee)* • stamp *(Hero Arts)*

WHAT YOU'LL NEED

Washable markers (various colors)
Lightweight cardstock
Water
Paper towels
Heat gun

Water mister
Background stamp
Permanent or archival-quality black ink pad

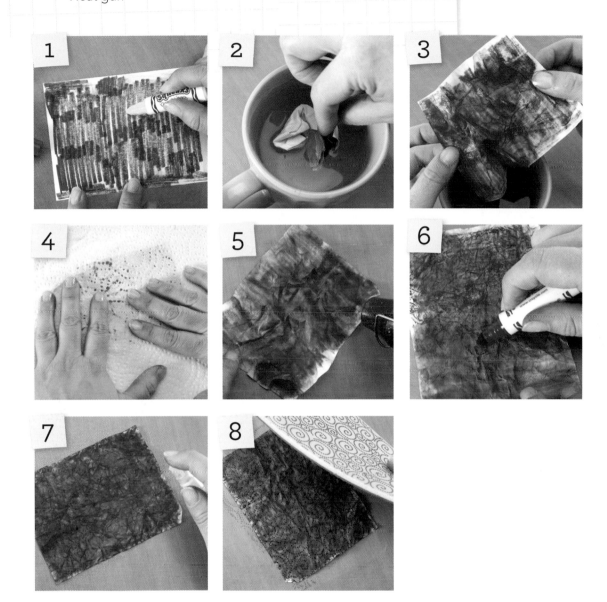

1 Color a piece of lightweight cardstock with washable markers. Apply blocks of color and blend the sections well.

2 Crumple and fold the cardstock and then dip it in a cup of water. Remove it once the entire piece is wet. (You can also try misting your paper with water.)

3 Gently open the folded cardstock.

4 Press the wet cardstock between two sheets of paper towel to remove the excess water.

5 Dry the damp cardstock with a heat gun. Be careful to avoid burning the cardstock. You should continue to crumple the cardstock as you dry it.

6 Color the dried cardstock with washable markers.

7 Mist the entire piece of colored cardstock with water. Press it between paper towels and then dry it with a heat gun.

8 Ink a background stamp and stamp the entire cardstock piece.

TISSUE PAPER DECOUPAGE

Yes, again, for the record, I love tissue paper. Adding texture with tissue paper makes me giddy! You can stamp on tissue and fold it to create creased layers, and it comes in about a million different colors. My heavens! I use Claudine Hellmuth Studio Multi-Medium by Ranger Industries to seal it. Once your piece dries, sand the edges for a superclean finish. This technique is perfect for all that chipboard most of us have.

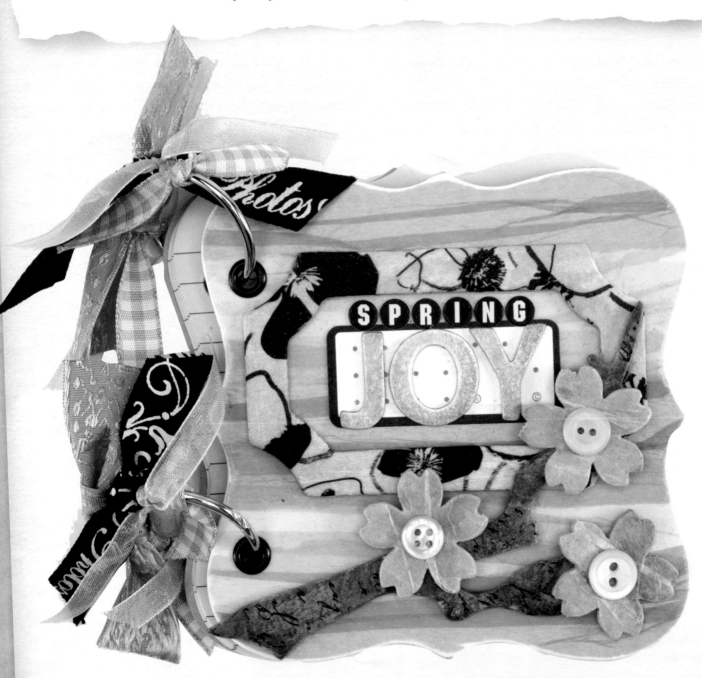

SPRING JOY MINI BOOK MATERIALS LIST

buttons • chipboard frame, branch and flowers *(Maya Road)* • chipboard letters *(BasicGrey)* • chipboard mini book *(Jenni Bowlin)* • gel medium *(Ranger Industries)* • inks *(Ranger Industries, Tsukineko)* • ribbons • stamps *(Hero Arts)* • tissue paper

WHAT YOU'LL NEED

Tissue paper

Artist-quality acrylic gel medium (matte)

Chipboard

Foam brush

Sandpaper

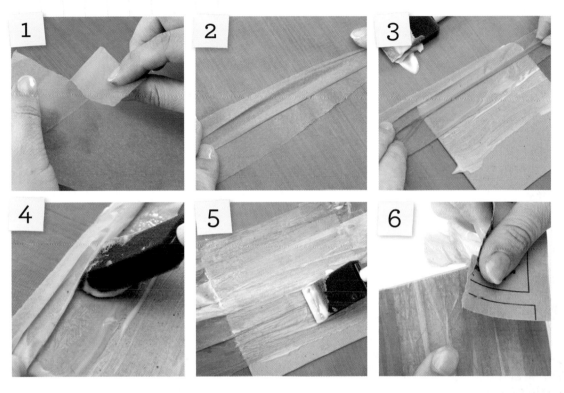

1 Tear tissue paper into strips.

2 Fold creases into the strips of torn tissue.

3 Apply a layer of gel medium to the chipboard using a foam brush. Add a strip of tissue paper over the gel medium.

4 Lift the folds in the tissue paper, and brush gel medium into them. Seal the entire strip of tissue with another layer of medium.

5 Repeat with the remaining strips of tissue paper until the entire piece of chipboard is covered.

6 Using a piece of sandpaper, sand the overhanging tissue paper away from the chipboard piece.

Details, Details

• Sandpaper is the quickest and cleanest way to remove any overhang on chipboard.

chapter three
SUPPLEMENTS

Complement, add to or enhance: That is what I had in mind for the supplements section of this book. Some of these techniques could easily fit into other chapters, but I thought they needed a home all their own. These unique ideas can be incorporated into a new layer of your project, or they can stand on their own.

Are you warmed up yet? Good. Now get ready for a little push … out of the proverbial box. Think *reduce, reuse, recycle*, along with a little bit of repurposing. In this chapter, we are going to use a few unexpected items to create small wonders. I can't wait to get you started!

So save that cardboard box, those used dryer sheets and candy wrappers. Rummage through the kids' stash for some craft foam, and go get some packing tape from the garage. Aren't you curious? Let's do this!

BURNISHED METAL

Metal finishes always seem to produce a certain wow factor. When using aluminum foil on a project, you get not only the look of metal, but also a hip, textural effect. This technique could easily be done with the foil alone, but the addition of chipboard letters and shapes under the foil creates extra dimension. The layers of light and dark paint also play up the creases and texture in the foil.

BURNISHED METAL MINI BOOK MATERIALS LIST

chipboard alphabet *(7gypsies)* • chipboard hearts *(Scenic Route Paper Co.)* • chipboard mini book *(Maya Road)* • craft glue • foil • gel medium *(Ranger Industries)* • metal rimmed tag *(Avery)* • metallic paint *(Viva Decor)* • paint *(Ranger Industries)* • patterned papers *(BasicGrey)* • ribbons • tabs *(BasicGrey)*

WHAT YOU'LL NEED

Craft glue

Chipboard shapes

Cardstock

Foam brushes

Artist-quality acrylic gel medium (matte)

Aluminum foil

Acrylic paints

Baby wipes or paper towels

Metallic or pearl paint

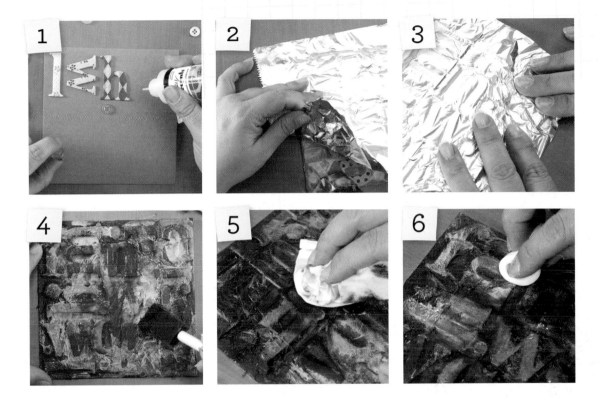

1 Glue the chipboard pieces onto the cardstock base.

2 Add a thin layer of gel over the chipboard pieces and lay the foil over the gel medium. Fold the edges under and secure them with medium.

3 Lightly rub the foil into place around the chipboard pieces using your finger. Be careful not to tear the foil.

4 Paint over the foil with a variety of different colors of acrylic paint. Allow the piece to dry completely.

5 Apply black acrylic paint to the entire piece and allow it to dry slightly. Buff the paint off the raised areas with a paper towel or nearly dry baby wipe, while leaving the paint in the crevices. Allow the black paint to dry completely.

6 Using a paper towel or soft cloth, randomly rub metallic or pearl paint onto the raised areas.

Details, Details

• After buffing off the black paint, some of the base colors may rub off. Reapply paint if necessary.

CANDY WRAPPER DECOUPAGE

One of the things that draws me to a yummy piece of candy is how it's packaged. In this case the goodies were foil-wrapped chocolate hearts. As I was devouring the bag, I started to accumulate a shiny pile of foil squares. They were too pretty to throw away, so I used them to cover a chipboard heart. Cool, huh?

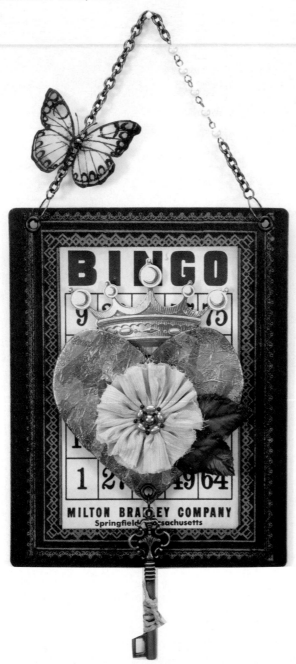

HANGING HEART MATERIALS LIST

adhesive (*Scrapbook Adhesives by 3L*) • bingo card (*My Mind's Eye*) • book cover (*7gypsies*) • chipboard heart (*Maya Road*) • die cut (*K&Company*) • eyelet (*We R Memory Keepers*) • flower embellishment (*Hero Arts*) • gel medium (*Ranger Industries*) • ink (*Ranger Industries*) • leaves (*7gypsies*) • key and chain (*7gypsies*) • stamps (*Hero Arts*) • paint (*DecoArt*) • pigment powder (*Ranger Industries*) • twine

WHAT YOU'LL NEED

Candy wrappers (foil, paper or plastic)

Foam brush

Artist-quality acrylic gel medium (matte)

Chipboard

Burnisher

Perfect Medium Stamp Pad

Perfect Pearls Pigment Powder

Water mister

Paper towels

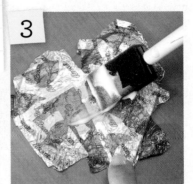
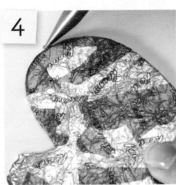
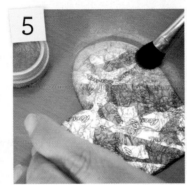
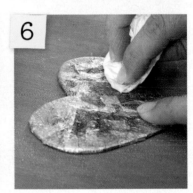

1 Smooth out the candy wrappers.

2 Brush a thick layer of gel medium over the chipboard and layer the candy wrappers on top.

3 Brush a layer of gel medium over the covered chipboard to seal the wrappers in place. Allow to dry completely.

4 Fold the edges of the foil under the chipboard and burnish into place.

5 Rub a small amount of Perfect Medium over the edges of the chipboard and immediately rub Perfect Pearls Pigment powder over the wet medium.

6 Lightly mist with water and buff with a paper towel to bind the mica powder to the chipboard.

Details, Details

- I like to use Perfect Pearls Pigments to add a shimmery finish because the Perfect Medium products help to bind the powders and also make application easier. Go ahead and test other mica products for similar results.

DRYER SHEET ART

Who doesn't love their laundry to be soft and springtime fresh? I, for one, do, and as a result, I have a mountain of used dryer sheets I feel guilty throwing away. The fibers and texture of used dryer sheets make them a fun textile to work with, and they accept color and stamps well. A dyed, used dryer sheet also works well as a textured, semitransparent overlay.

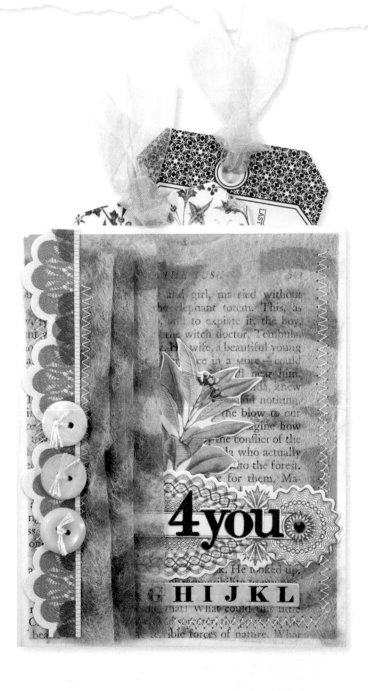

4 YOU CARD MATERIALS LIST

adhesive (*Scrapbook Adhesives by 3L*) • book pages • border (*Sassafras*) • buttons • card (*Hero Arts*) • die cuts (*7gypsies*) • mask (*Maya Road*) • ribbons • spray ink (*Tattered Angels*) • stickers (*Webster's Pages*) • tags (*7gypsies*) • thread • used dryer sheet

WHAT YOU'LL NEED

Iron

User dryer sheet

Spray ink (two or more colors)

Mask (I used a stencil)

Details, Details

- Background stamps can be used to dress up the masked image. Simply stamp the dryer sheet after the ink has dried.

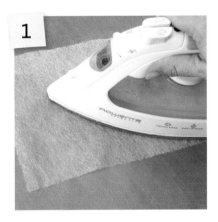 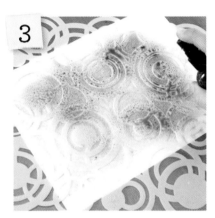

1. Iron a used dryer sheet. Use low heat and be careful not to burn or melt the dryer sheet.

2. Mist with a light color spray ink. Allow the dryer sheet to dry.

3. Lay a mask on top of the dryer sheet and spray it with a darker color of spray ink. Allow it to dry.

A Little Something Extra:

WASTE NOT, WANT NOT

Don't waste the ink or mist that covers the stencil. Flip the stencil over and press it onto another dryer sheet or piece of cardstock. Highlight the design with a second color of spray ink, allow the piece to dry completely and then reveal the "positive" image.

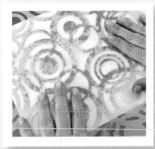 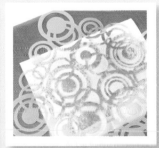 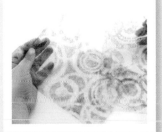

FOAM STAMPS

You have probably noticed that I am not above raiding my kids' craft boxes for things to add to my art. This especially is one time when I am so glad I did. I love making stamps and printing plates from sheets of craft foam! This is so ridiculously easy and inexpensive. I guarantee—yes, I said *guarantee*—that you will love this one. The possibilities are infinite!

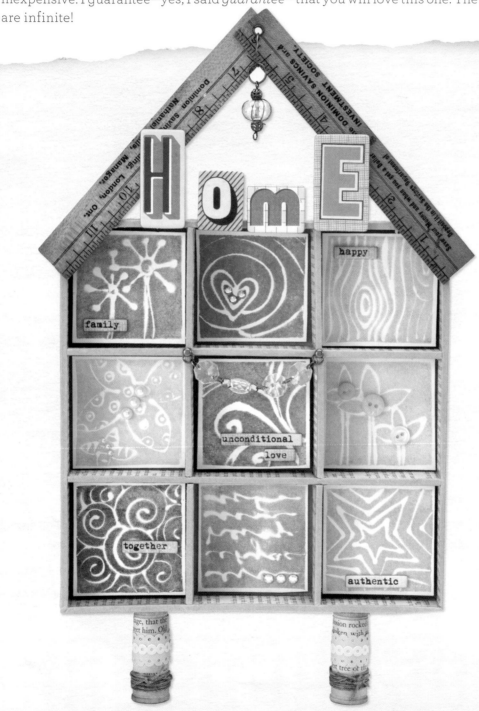

HOME SHADOW BOX DECOR MATERIALS LIST

adhesive (*Beacon Adhesives, Stix 2 Kool Tak, Scrapbook Adhesives by 3L*) • beaded chain (*7gypsies*) • book pages and borders (*Doodlebug Design*) • brads (*7gypsies*) • charm (*Blue Moon Beads*) • chipboard (*GCD Studios, Sassafras*) • craft foam • ink (*Distress Ink, Ranger Industries*) • jump ring (*7gypsies*) • rhinestones and pearls (*Queen & Co.*) • ruler • shadow box (*Maya Road*) • spools • twine

WHAT YOU'LL NEED

Craft foam sheet

Scissors

Pencil

Stylus or ball burnisher

Brayer

Distress Ink or dye-based
ink pad

Cardstock

Heat gun

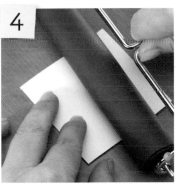

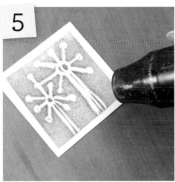

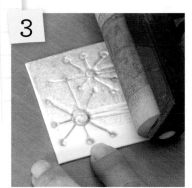

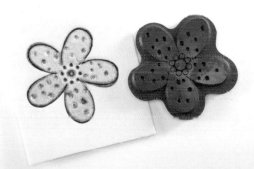

1 Cut pieces of craft foam to the desired size and draw a pattern on each piece with a pencil.

2 Using a stylus, trace the pattern to create deep indentations.

3 Roll a brayer across an ink pad and apply the ink to the craft foam.

4 Place a piece of cardstock over the inked foam and rub to transfer the image.

5 Use a heat gun to set the ink.

Details, Details

• For repeated use of your stamp, add stability by attaching a piece of cardboard to the back with craft glue.

GLITTER TAPE

Glitter always adds the perfect amount of sparkle to a project, but working with wet glue can be messy and time consuming. Adding glitter to packing tape is a quick and easy solution. The translucency of the tape also allows light to pass through it for an interesting effect. Packing tape is another one of those household items most of us have on hand, and this is a great crafting use for it.

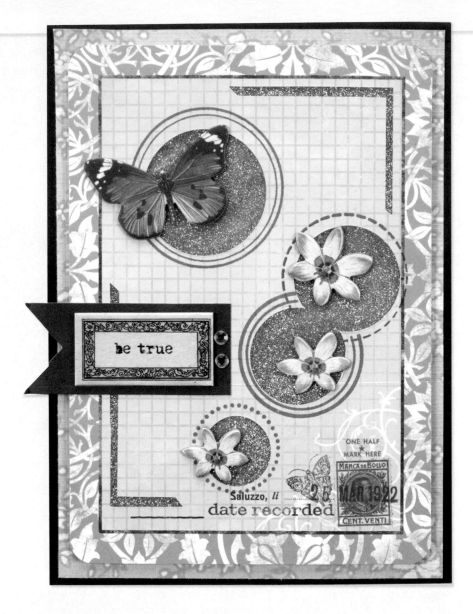

BE TRUE CARD MATERIALS LIST

adhesive (*Scrapbook Adhesives by 3L*) • cardstock (*Core'dinations*) • chipboard (*BasicGrey, GCD Studios*) • circle cutter (*Fiskars*) • glitter (*EK Success*) • ink (*Ranger Industries*) • journal page (*7gypsies*) • packing tape • patterned paper (*BoBunny Press, GCD Studios*) • rhinestones (*Queen & Co.*) • stamps (*Papertrey Ink*)

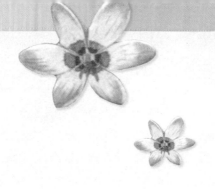

WHAT YOU'LL NEED

Cardstock

Paper punch, die-cutting machine or scissors

Clear packing tape

Glitter (fine textured)

Foam brush

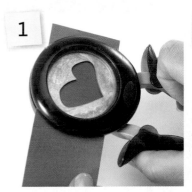

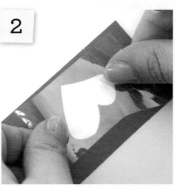

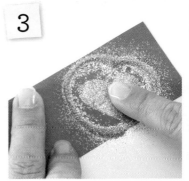

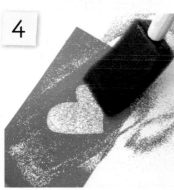

1 Cut a shape from a piece of cardstock with a punch, die-cutting machine or by hand.

2 Place a piece of packing tape on the back side of the cardstock to cover the cutout.

3 Cover the tacky side of the tape with glitter and rub the glitter into the tape.

4 Brush off any extra glitter with a clean foam brush.

A Little Something Extra:
DOUBLE-SIDED GLITTER TAPE

This technique will also work with double-sided tape. Add glitter to one side of the tape and then attach the tape to your project to create a sparkly border, as Jennifer McGuire did with her Smile card (see page 120). Not only will you be adding sparkle, you'll also be adding texture!

MASKING TAPE

I remember that once, when I was a little girl, my brother made a candleholder out of a bottle covered in masking tape. The tape was stained orange and red, and I thought it was the coolest thing ever. One of the current trends in the crafting industry is printed tapes, and I knew right away what I had to make! I used Distress Inks from Ranger Industries to color the tape, and the inks worked well to highlight the texture of the tapes.

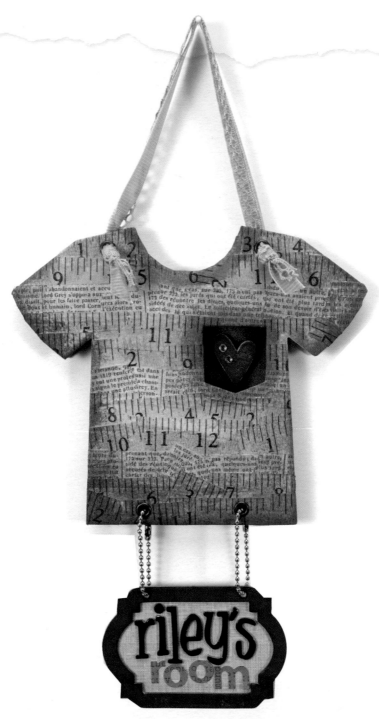

RILEY'S ROOM DOORKNOB HANGER MATERIALS LIST

adhesive (*Scrapbook Adhesives by 3L*) • chipboard (*Maya Road*) • eyelet (*We R Memory Keepers*) • letters (*American Craft, Sassafras*) • ink (*Ranger Industries*) • masking tape (*7gypsies*) • patterned paper (*Sassafras*) • rhinestones (*Queen & Co.*) • ribbon • spray ink (*Ranger Industries, Tattered Angels*)

WHAT YOU'LL NEED

Masking tape (printed or plain)
Chipboard shape
Ball burnisher
Distress Ink or other spray ink
Baby wipes or paper towels
Nonstick craft mat

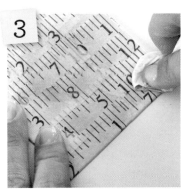

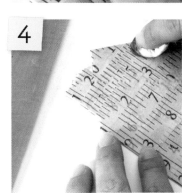

1 Tear strips of masking tape and layer them on a chipboard shape. Wrap the masking tape around the edges of the piece for a clean finish.

2 Once the tape is applied, burnish all the edges to prevent the tape from lifting.

3 Spray ink directly onto the taped piece and, using a damp paper towel or baby wipe, rub the ink around to cover the entire piece. Make sure the towel is only damp; otherwise you risk removing ink. Allow the piece to dry completely.

4 To apply a second, darker shade of ink, spray ink onto a nonstick craft mat and dip a baby wipe or damp paper towel into the ink. Rub the ink around the outer edges of the chipboard piece to create depth. Allow it to dry completely.

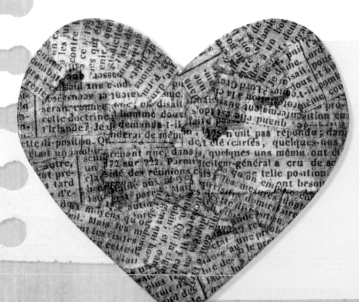

A Little Something Extra:
MASK WITH TAPE

Cover the entire piece of chipboard with strips of masking tape. Mask certain areas with small pieces of tape, and mist with a darker shade of ink (blue, in this case). Remove the smaller masks and rub a second color (here, red) over the entire piece. This technique creates a two-tone look.

HEART TAG MATERIALS LIST

chipboard heart *(Maya Road)* • ink *(Ranger Industries)* • spray ink *(Ranger Industries)* • tape *(7gypsies)*

PAPER PIECING

Paper piecing is near and dear to my heart. I love breaking things down to their most basic shapes and re-creating them in layers of paper. That's the trick behind piecing. First, simplify the thing you are trying to make by looking at it as a bunch of separate shapes. Next, break it down by color. Finally, put it back together to create a paper piecing. For this technique, you can use a die-cutting machine or you can stamp or hand- draw your shapes and then use my favorite tool, the craft knife, to cut them out.

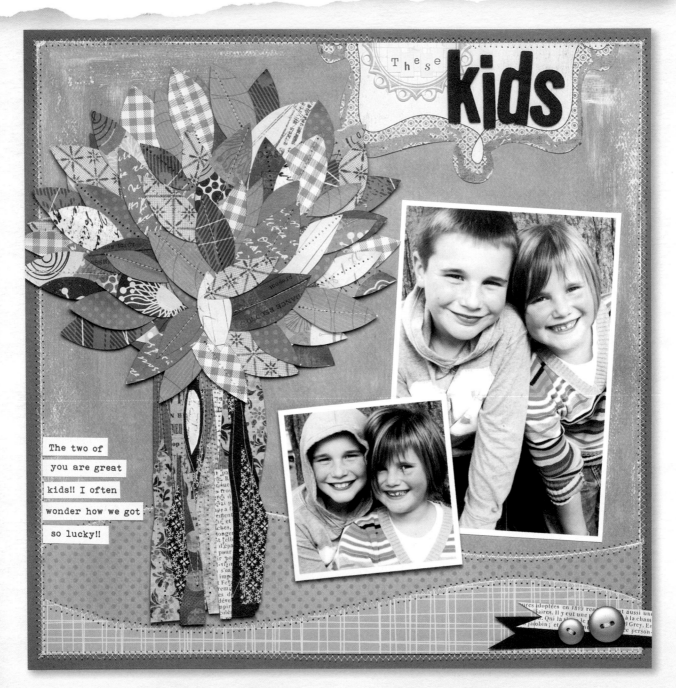

THESE KIDS PAPER PIECED TREE LAYOUT MATERIALS LIST

adhesive (Ranger Industries, Scrapbook Adhesives by 3L) • buttons (American Crafts) • cardstock (Prism Papers) • patterned paper (BasicGrey, BoBunny Press, Cosmo Cricket, Crate Paper, Imaginisce, Kaisercraft, Making Memories, 7gypsies) • stickers (My Little Shoebox) • tags (BasicGrey, K&Company)

WHAT YOU'LL NEED

Scissors or a craft knife

Cardstock

Decorative scrapbooking paper in various shades of green and brown

Sewing machine

Thread

Glue

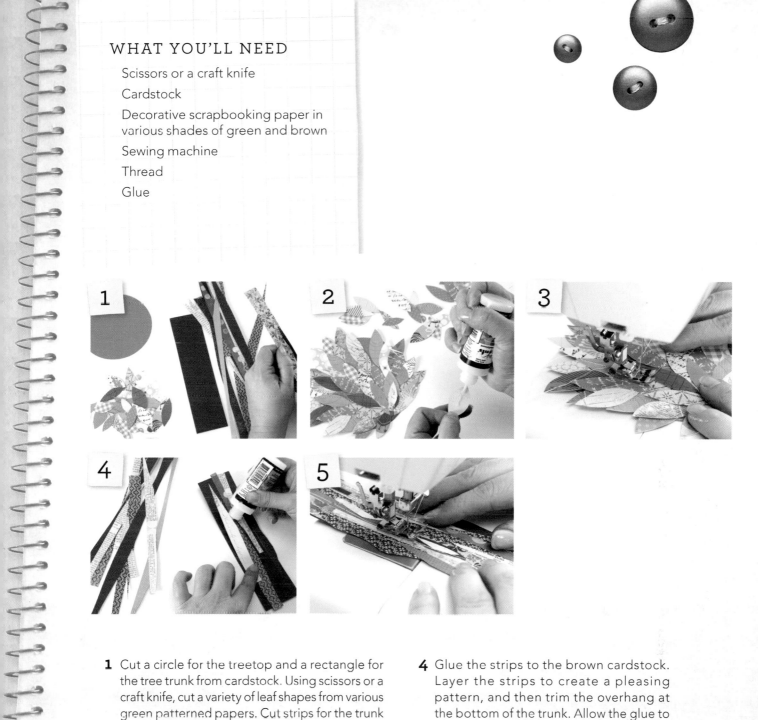

1. Cut a circle for the treetop and a rectangle for the tree trunk from cardstock. Using scissors or a craft knife, cut a variety of leaf shapes from various green patterned papers. Cut strips for the trunk from different brown patterned papers.

2. Glue the leaf cutouts to the cardstock circle, starting from the bottom of the circle and moving up toward the top. Allow the glue to dry completely.

3. Using a sewing machine, sew a line through the center of a number of the leaf shapes. Remove the thread from the needle and sew the stitch pattern on a few of the leaves.

4. Glue the strips to the brown cardstock. Layer the strips to create a pleasing pattern, and then trim the overhang at the bottom of the trunk. Allow the glue to dry completely.

5. Sew vertical lines up and down the trunk of the tree. Assemble the tree.

PAPER TOWEL ART

Paper towels are a perfect medium for inks, dyes and paints: They are absorbent, they have body and they have a built-in quilted texture. They can also be stitched, stamped and drawn on. Another key feature is that they can be altered by accident through the simple act of cleaning up! Remember to save any paper towels you use to clean up your spray inks. This will save you time and money, and it's a great way to go green.

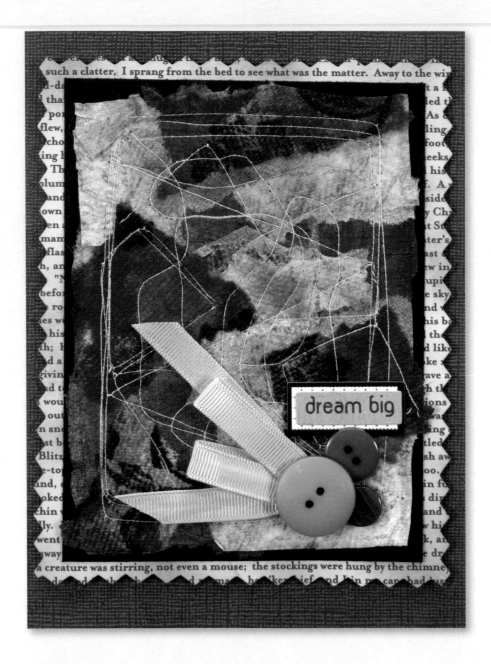

DREAM BIG CARD MATERIALS LIST

adhesive (*Scrapbook Adhesives by 3L*) • buttons (*BasicGrey*) • cardstock (*Core'dinations*) • decorative scissors (*Fiskars*) • ink (*Ranger Industries*) • paper towels • patterned paper (*October Afternoon*) • ribbon • spray ink (*Maya Road*) • stamps (*Hero Arts*) • stickers (*BasicGrey, Crate Paper*) • thread

WHAT YOU'LL NEED

Nonstick craft mat

Water mister

Paper towels

Spray ink (several colors)

Heat gun

Stamps

Permanent or archival-quality black ink

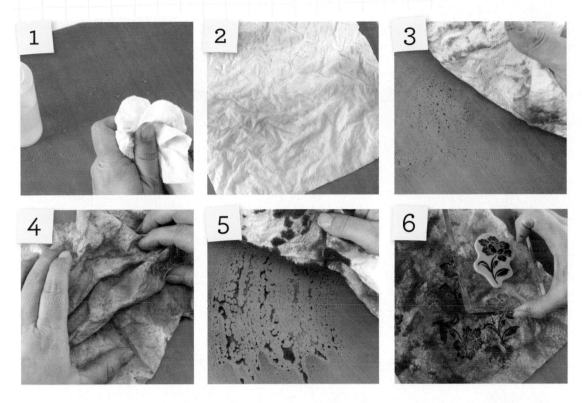

1 Working on a nonstick craft mat, lightly mist a paper towel with water and then crumple it in your hand. A thick, two-ply brand will work best.

2 Open the paper towel and mist it lightly with the lightest shade of ink. Wipe the overspray off the craft mat and dry the paper towel with a heat gun. Do not overheat the paper towel—it could burn.

3 Mist the paper towel with the medium shade of spray ink and then wipe the overspray off the craft mat with the paper towel. Dry with a heat gun.

4 Fold creases into the paper towel.

5 Mist the nonstick craft mat with the darkest shade of ink and drag the folded paper towel through the ink. Open the paper towel and dry with a heat gun.

6 Stamp images or background stamps onto the colored paper towel.

Details, Details

- To create an interesting quilted look, stamp, tear and sew together different colors of paper towel.

- Always keep the paper towels you've used for ink or paint cleanup—they can be used in future projects.

STICKER MASKING

Stickers are one item I seem to have a lot of. There are letter stickers (with only a few of the vowels left), shape stickers and theme stickers in my stash that I have grown bored with. But using the stickers as a mask with inks, paints and spray inks gives them a new lease on life. For this project, I used a typography approach by layering letter stickers to create words within a die-cut shape. Not only did this technique help me use up leftover stickers, I was also able to find a use for a leftover negative die-cut shape.

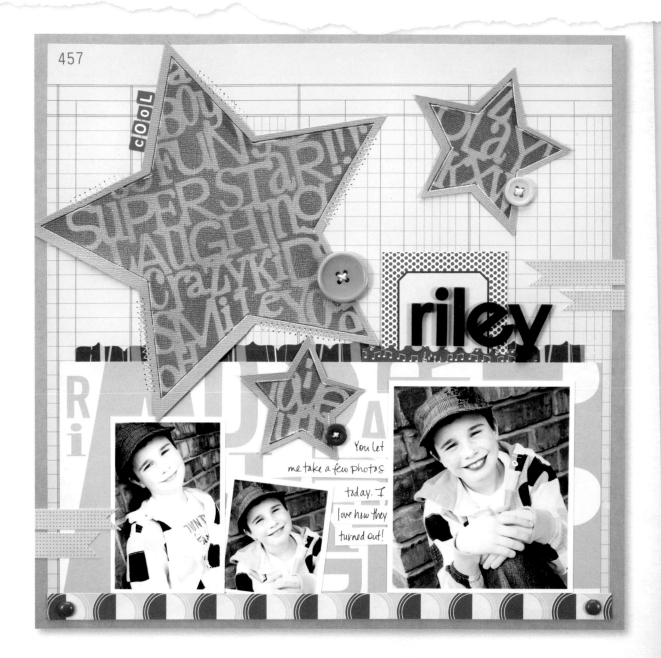

RILEY LAYOUT MATERIALS LIST

adhesive (*Scrapbook Adhesives by 3L*) • brads (*BasicGrey*) • buttons (*Foofala*) • cardstock (*Core'dinations*) • die-cutting machine (*Silhouette*) • ink (*Ranger Industries*) • letters (*Cosmo Cricket, Queen & Co.*) • letter stickers for mask • paper punches (*Fiskars*) • patterned paper (*Cosmo Cricket, October Afternoon, Sassafras*) • pens (*American Crafts, Uni-ball*) • spray ink (*Maya Road*) • tag (*Cosmo Cricket*) • thread

WHAT YOU'LL NEED

Cardstock (two pieces)
Repositionable adhesive
Foam sponge or blending tool
Distress Ink or dye-based ink pad
White gel pen
Black marker
Spray ink
Stickers

1 Cut a mask from cardstock. Place the mask over a piece of cardstock and layer stickers over the opening of the mask to create a pattern. Here I'm using letter stickers to create word art.

2 Rub ink over the letter stickers with a foam sponge or blending tool.

3 Remove the stickers to reveal the masked effect.

4 Lay the mask over the word art and outline the mask with a white gel pen and a black marker.

5 Shift the mask off-center slightly and lightly mist the area with a light shade of spray ink. Allow to dry completely.

Details, Details

• There are so many variations to this technique. I like to think of it as a mask within a mask. Try it with chipboard, stencils and even the gel medium resist technique from Chapter One (see page 14).

WHITE GLUE STAMP

This technique is another take on printmaking, but I modified it a bit to create a stamp. White glue dries with a bit of dimension, so it is perfect for creating a relief image. And while you can use a pen or a pencil or even a marker to create your design, I also want to recommend chalk ink—it works especially well with this technique. The sky is the limit as far as your design is concerned, and this is one your that kids can get involved in.

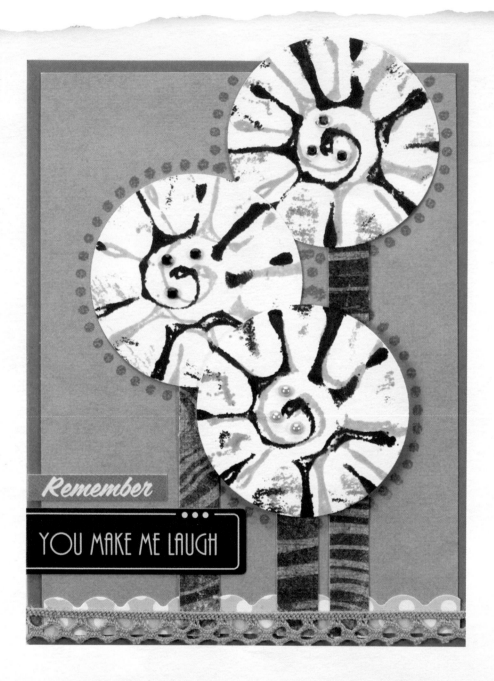

YOU MAKE ME LAUGH CARD MATERIALS LIST

adhesive (Elmer's, Scrapbook Adhesives by 3L) • card (Hero Arts) • cardstock (Core'dinations) • ink (Hero Arts, Ranger Industries) • patterned paper (Three Bugs in a Rug, My Mind's Eye) • rhinestones/pearls (Hero Arts) • ribbon • stamps (Fiskars) • stickers (Jillibean Soup, Studio Calico)

WHAT YOU'LL NEED

Pen or pencil
Cardboard
White glue
Brayer
Ink pad of your choice
Paper

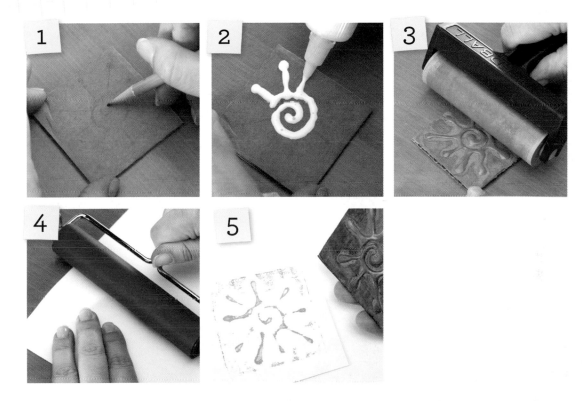

1 Use a pen or pencil to draw a design on a piece of cardboard.

2 Trace over the design with white glue and allow it to dry overnight.

3 Ink a brayer and roll the ink over the glue image.

4 Place a piece of paper on top of the image and rub your hand or run a brayer over the paper to transfer the image.

5 Lift the paper to reveal the image.

Details, Details

- You may need to experiment with the type of white glue you use. The glue needs to have dimension when dry.

- The technique can be used with any images. Simply outline an image with white glue.

chapter four
EMBELLISHMENTS

It's time for the finishing touch, the pièce de résistance . . . the embellishments! I lovingly refer to this step in the process as "adding the jewelry." It is usually the final phase in a project, and it's undeniably the most pleasurable. Think of it as the cherry on top!

The fun, finicky and fussy-cutting part is about to begin. This chapter is all about spotlighting the fine details that make a project special. We will focus our attention on using beads, playing with pigment powders and making lots of flowers. Some of these techniques are time-consuming, but the finished product will be well worth the effort. Remember that the details are what can take a piece from good to great!

The materials in this section vary as greatly as the techniques you are about to try. Substitute and alter if the need arises. Once again, it's time to experiment and make it your own. I know you can do it. Practice, practice, practice! Play, play, play!

BEADED RIBBON RUFFLE

Beads and ruffles are pretty on their own, but they become even lovelier paired together. I love the softness that ribbons add to paper projects, and the stitched beads complement the gathered look. When working with this technique, plan to double the length of the ribbon you require for your finished piece in order to accommodate the gathers.

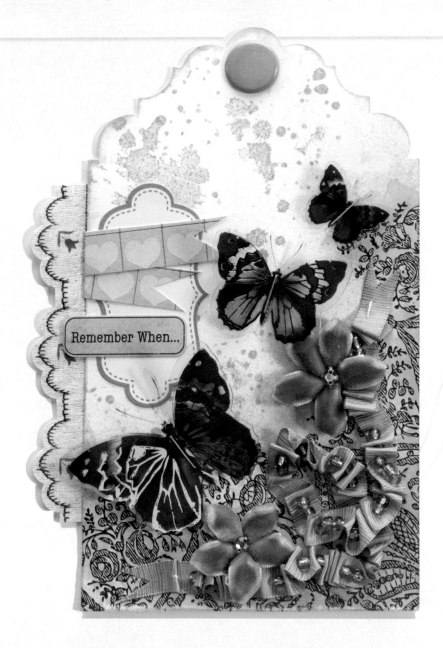

REMEMBER WHEN TAG MATERIALS LIST

adhesives (*Beacon Adhesives, Scrapbook Adhesives by 3L*) • border (*Sassafras*) • brads (*American Crafts*) • butterfly embellishments (*Michaels*) • embroidery floss • flower embellishments (*Maya Road*) • glass beads • inks (*Ranger Industries*) • patterned paper (*Sassafras*) • ribbon (*American Crafts*) • stamps (*Stampers Anonymous*) • staples • stickers (*Bella BLVD, Webster's Pages*) • tag (*Tattered Angels*)

WHAT YOU'LL NEED

Scissors
Decorative ribbon
Glass beads
Thread
Needle

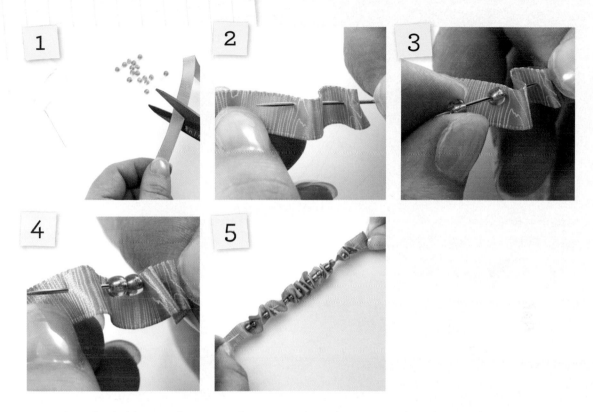

1 Cut a length of ribbon, collect your glass beads and thread a needle.

2 Make a knot in the thread and pass it through one end of the ribbon. Make a loose fold in the ribbon near the end, and pass the threaded needle through it.

3 Thread one or two beads onto the needle.

4 Pull the thread through the ribbon to create a pleat.

5 Continue to stitch pleats and beads into the ribbon until the ribbon is of desired length.

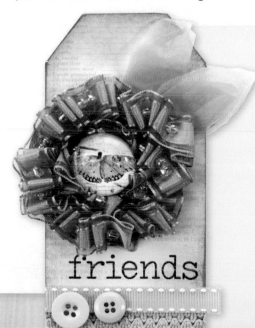

A Little Something Extra:
BEADED RIBBON FLOWER

Use a wider ribbon to create a beaded flower. Follow the instructions above, and then coil the ribbon into a flower shape. Glue the flower to a cardstock base using Fabri-Tac glue, which is specially formulated for use with fabric.

FRIENDS RIBBON FLOWER TAG MATERIALS LIST

adhesive (*Scrapbook Adhesives by 3L*) • bauble (*Michaels*) • beads (*Blue Moon Beads*) • chipboard tag (*Maya Road*) • inks (*Ranger Industries*) • lace (*Maya Road*) • patterned paper (*Little Yellow Bicycle*) • ribbon (*Michaels*) • stamp (*Hero Arts*)

CARDSTOCK FLOWERS

Punched and die-cut flowers come in a multitude of shapes and sizes, and they make great embellishments. By manipulating these flower shapes with water and heat, you can create beautiful, dimensional blossoms. Cardstock is a perfect material to work with, due to its weight and stability. It will hold up to handling, and it retains its shape well. These flowers are so much fun to make!

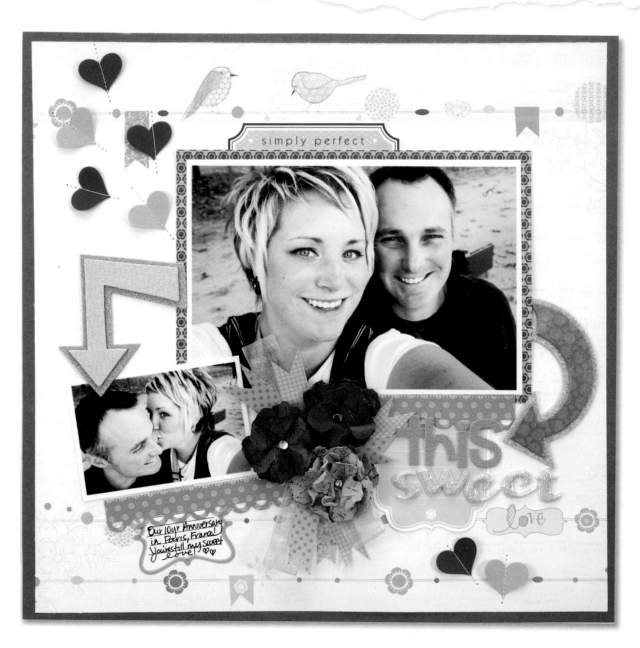

THIS SWEET LOVE LAYOUT MATERIALS LIST

adhesive (*Scrapbook Adhesives by 3L*) • cardstock (*Core'dinations, Bazzill Basics*) • die cuts (*Sizzix*) • die-cut machine (*Sizzix*) • ink (*Ranger Industries*) • letters (*American Crafts, Prima Marketing*) • paper punches (*Fiskars*) • patterned paper (*Doodlebug Design, Little Yellow Bicycle*) • pen (*American Crafts*) • rhinestones (*Queen & Co.*) • ribbon (*Michaels*) • stamp (*Hero Arts*) • stickers (*Bella BLVD, Little Yellow Bicycle*)

WHAT YOU'LL NEED

Cardstock flower shapes
(paper-punched, die-cut
or handcut)

Background stamp

Permanent or archival-
quality black ink pad

Water mister

Heat gun

Craft glue

Rhinestones

Tweezers

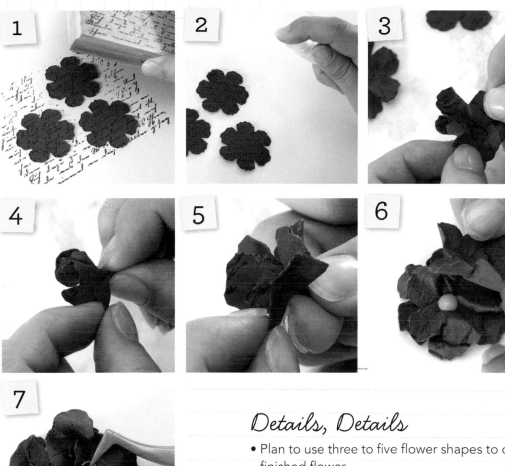

Details, Details

- Plan to use three to five flower shapes to create each finished flower.

- Heat setting the flowers once they are shaped allows the paper to retain the memory of the fold; the flowers will maintain their shape once heated and dried. Be careful not to burn the paper . . . or your fingers!

1 Stamp flower shapes with a background stamp and permanent or archival-quality ink. (This step is optional—your flower can be created without ink).

2 Mist the flower shapes with water. Wetting the paper allows it to be manipulated more easily and also reduces tearing.

3 Gently crumple the flower shapes and then open them back up.

4 Shape two of the flowers and dry them with a heat gun.

5 Pinch and twist the middle of the third flower and shape the leaves so it will fit into the center of the first two flowers. Dry the flower shape with the heat gun.

6 Glue the three shaped flowers together.

7 Add a rhinestone center. Tweezers make this easier.

CUPCAKE WRAPPER FLOWERS

Cupcakes are yummy and so are the patterns on the wrappers that encase them. With the huge assortment of patterns available in cupcake wrappers, your flower options are almost endless. The circular shape and built-in texture create pretty pom-pom-like blossoms. They also come in a variety of sizes so you can play around with the scale of your flowers.

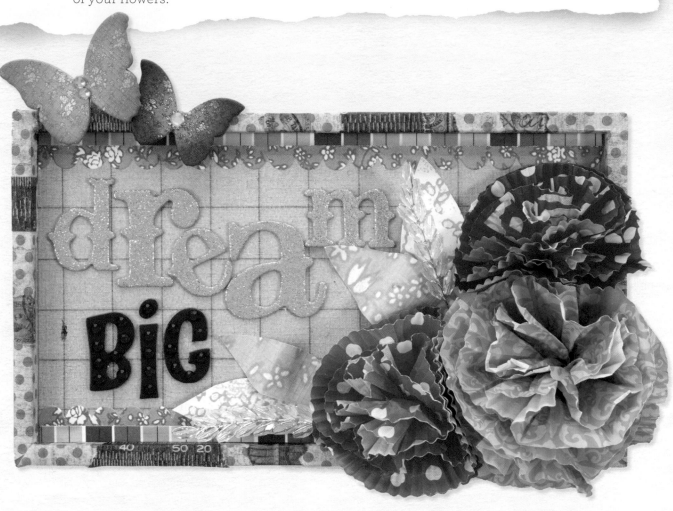

DREAM BIG FRAME MATERIALS LIST

adhesive *(Ranger Industries, Stix2–kool tak)* • baking cups/cupcake wrappers • beaded floral spray • chipboard butterflies *(Jenni Bowlin)* • die cuts *(GCD Studios)* • letters *(American Crafts, Pink Paislee)* • patterned paper *(Sassafras)* • rhinestones *(Queen & Co.)* • tape *(7gypsies)*

WHAT YOU'LL NEED

Decorative cupcake wrappers
Small hole punch or awl
Decorative brad

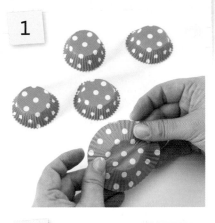

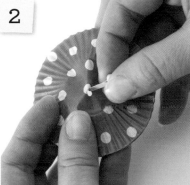

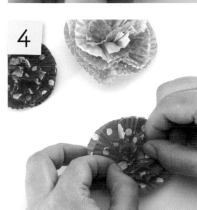

1 Flatten out five cupcake wrappers.

2 Layer the wrappers together and punch a hole in the center. Attach a brad through the hole.

3 Lift and crinkle the top layer to create texture. Repeat with each layer.

4 Shape the layers to make a flower.

Details, Details

• The variety of cupcake wrappers available is nearly endless. Vary the size and color of wrappers for countless possibilities.

EMBOSSED METAL CHIPBOARD

For quick coverage of chipboard pieces, aluminum foil tape comes in handy. Its adhesive backing makes for quick work and eliminates the need for messy glues. Once the chipboard is covered, any embossed pattern can easily be added and highlighted with paint. This is yet another quick way to add pizzazz to chipboard pieces.

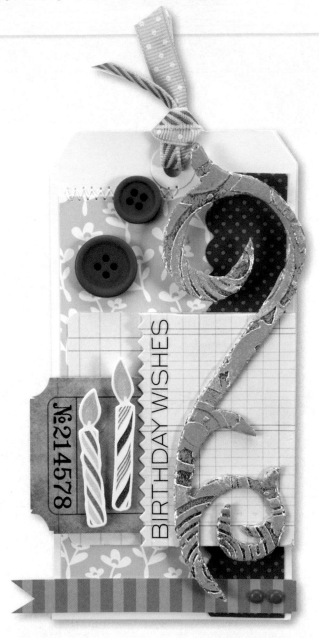

BIRTHDAY WISHES TAG MATERIALS LIST

adhesives (*Scrapbook Adhesive by 3L, Stix2–kool tak*) • buttons (*American Crafts*) • chipboard (*American Crafts, Maya Road*) • die-cutting machine (*Sizzix*) • embossing folder (*Sizzix*) • paint (*DecoArt*) • patterned paper (*American Crafts*) • pocket (*KI Memories*) • ribbon (*American Crafts, Michaels*) • rub-ons (*American Crafts*) • ticket (*Tim Holtz idea-ology*)

WHAT YOU'LL NEED

Chipboard shape

Metal tape

Scissors or a craft knife

Burnishing tool

Embossing folder and die-cutting machine

Acrylic paint

Paintbrush or foam brush

Paper towels

 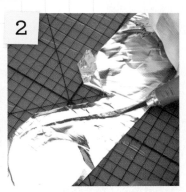 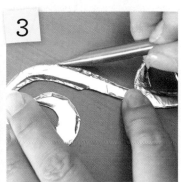

 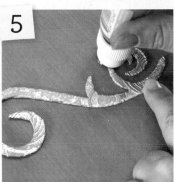

1 Cover a chipboard shape with metal tape.

2 Trim or cut away any excess metal tape with scissors or a craft knife. Leave a slight border around the shape to cover the sides of the chipboard.

3 Fold over the metal overhang to cover the sides of the chipboard shape and rub the edges of the chipboard shape with a burnishing tool.

4 Place the metal-covered chipboard shape inside an embossing folder and run it through a die-cutting machine.

5 Add a layer of acrylic paint to the embossed chipboard shape with a paintbrush or foam brush. Allow the paint to dry slightly and then buff off some of the paint with a paper towel.

A Little Something Extra:
EMBOSSED METAL WITH ALCOHOL INKS

Another great way to add color to metal is with Ranger's Adirondack Alcohol Ink. That's what I did here with the embellishment on my Thanks Monogram *card (see page 109), and notice how completely different the look is from the acrylic-painted embellishment.*

FABRIC FLOWERS

Fabric flowers are all the rage in fashion. With a few strips of muslin you can make these rolled fabric flowers in minutes. The length of muslin needed is dependent on how tight you roll the flower and how big you want it. The sample here is a brooch, but these flowers can be added to cards, mini books and canvases, too.

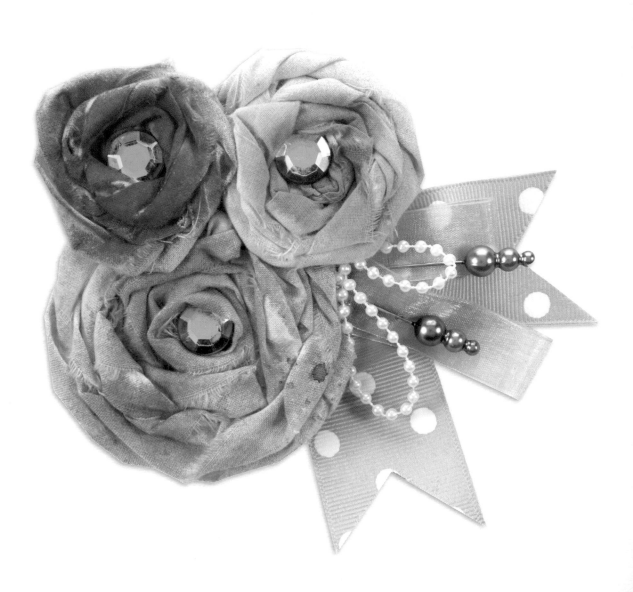

FABRIC FLOWERS BROOCH MATERIALS LIST

beaded ribbon (*Michaels*) • muslin • pins (*Maya Road*) • ribbon (*Michaels*) • rhinestones (*Prima Marketing*) • spray ink (*Maya Road, Tattered Angels*)

WHAT YOU'LL NEED

Strip of muslin approximately 2 (5cm) wide (see Details, Details for help in determining length)

Fabric glue

Cardstock circle (slightly smaller than you want the finished flower to be)

Scissors

Spray ink

Heat gun

Button or other embellishment

Details, Details

• Fabric length is dependent on the size of the flower and how tightly it is wrapped. For example, a small flower might use a 16" (41cm) piece of muslin. A medium flower might use 22" (56cm) of muslin. A large flower might use 30" (76cm) or more of muslin. Experiment to figure out what sizes and lengths work best for your tastes.

• You can substitute a hot glue for the fabric glue.

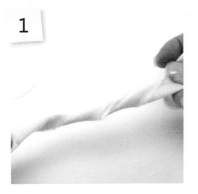

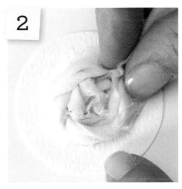

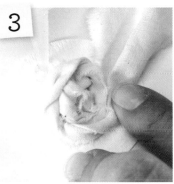

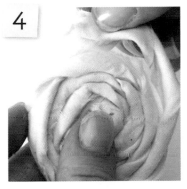

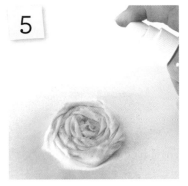

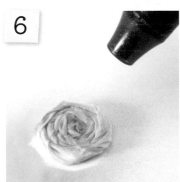

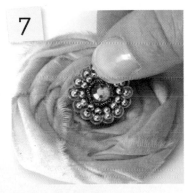

1 Twist the muslin strip.

2 Add a dot of fabric glue to the center of the cardstock circle. Twist the end of the muslin strip and press it into the glue.

3 Continue to twist and coil the muslin around the center, adding glue as needed to secure the fabric in place.

4 When the flower is the desired size, trim off any excess fabric. Tuck the tail of the fabric under and secure with fabric glue. Allow the glue to dry completely.

5 Mist the flower with spray ink.

6 Dry the flower with a heat gun.

7 Add a button or other embellishment to the center of the rolled flower with fabric glue.

FOIL TRANSFER

Sparkle, shimmer and shine are the perfect ways to dress up an embellishment. You can use the traditional gold and silver foils or kick it up a notch with colored foils like these from Stix2–kool tak. Adding a sheet of double-sided adhesive to cardstock and running it through a die-cutting machine makes this technique so much easier than using wet adhesives. Simply cut your adhesive shapes and apply foil and glitter in sections.

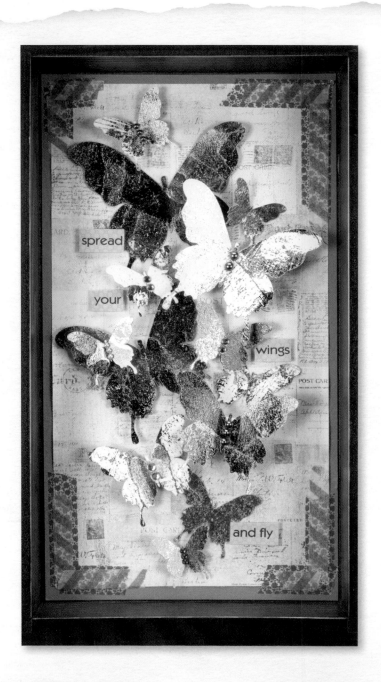

SPREAD YOUR WINGS AND FLY LIBRARY DRAWER MATERIALS LIST

adhesives (*Scrapbook Adhesives by 3L, Stix2–kool tak*) • butterfly die cuts (*Silhouette*) • cardstock (*Core'dinations*) • double-sided adhesive sheet (*Scrapbook Adhesives by 3L*) • foil (*Stix2–kool tak*) • glitter (*EK Success*) • library drawer (*7gypsies*) • patterned paper (*7gypsies*) • rhinestones/pearls (*Queen & Co.*) • stickers (*Little Yellow Bicycle*) • tape

WHAT YOU'LL NEED

Cardstock
Sheet of double-sided adhesive
Paper punch or die-cutting machine

Transfer foil (several colors)
Glitter

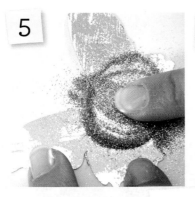

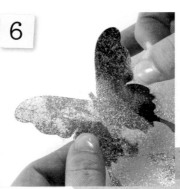

1 Cover a piece of cardstock with a sheet of double-sided adhesive. Die-cut or punch shapes from the adhesive-covered cardstock.

2 Tear part of the backing from the adhesive-covered cardstock shape.

3 Cover the adhesive with foil and gently rub on the foil with your finger to release. The foil should adhere only to the exposed adhesive.

4 Tear more of the backing from the adhesive-covered cardstock shape and add a second foil color over the first. This time, burnish the foil over the entire exposed adhesive area.

5 Tear another section of backing off the shape, add glitter to the adhesive area and burnish.

6 Tap the piece to remove excess glitter.

Details, Details

- To ensure you are transferring the foil rather than adhering the clear-sided backing to the adhesive, you'll have to confirm which side the foil releases from. Usually there is a shiny side and a dull side to the foil. The dull side should be placed onto your adhesive surface. When working with colored foil, always have the colored side facing up.

- Glitter should always be the last step because it goes everywhere! You cannot control the placement of the glitter like you can the foil.

HEAT-EMBOSSED CHIPBOARD

Ultra Thick Embossing Enamel (also known as UTEE) is great for building layers that can then be stamped into. The effect is an embossed relief pattern. By adding pigment powders, the design can be highlighted and defined. The finished look is stunning.

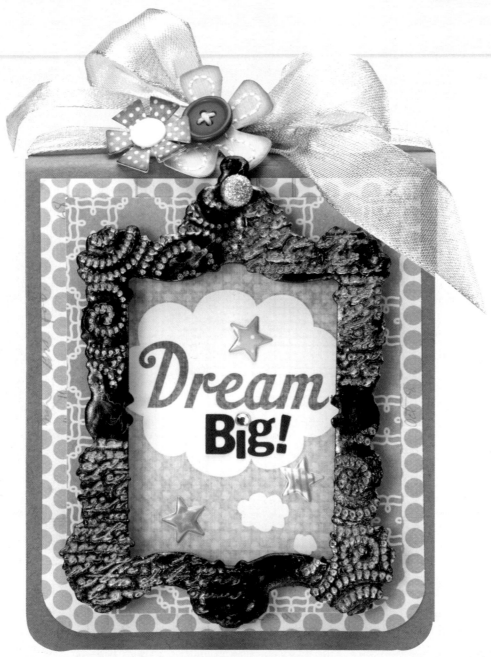

DREAM BIG MINI BOOK MATERIALS LIST

adhesives *(Scrapbook Adhesives by 3L)* • brads *(American Crafts)* • embossing ink • embossing powder *(Ranger Industries)* • flower embellishments *(Sassafras)* • frame *(Darcie's)* • inks *(Hampton Art, Ranger Industries)* • letters *(BasicGrey)* • mini book *(Maya Road)* • patterned paper *(Sassafras)* • pigment powders *(Ranger Industries)* • rhinestones *(Queen & Co.)* • ribbon • star embellishments *(Making Memories)* • tag *(My Mind's Eye)* • stamps *(Hero Arts)*

WHAT YOU'LL NEED

Permanent or archival-quality black ink pad

Chipboard frame

Heat gun

Embossing ink pad

Ultra Thick Embossing Enamel (UTEE)

Metallic pigment ink

Rubber stamp

Paintbrush

Pigment powder

Paper towels

Water mister (optional)

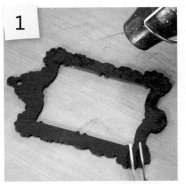

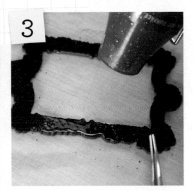

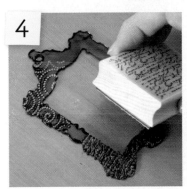

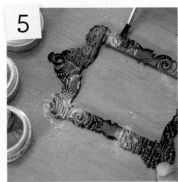

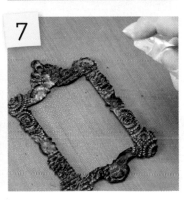

1 Rub a black ink pad on a chipboard frame. Dry the ink with a heat gun.

2 Rub the frame with embossing ink and immediately cover the frame with black UTEE.

3 Heat-set the UTEE. Repeat Steps 2 and 3 two more times.

4 Ink a stamp with metallic ink. Heat the UTEE-covered frame and stamp into the hot UTEE.

5 Brush pigment powder into the stamped areas.

6 Buff off excess pigment powder with a paper towel.

7 Set the pigment powder by misting it with water, if necessary.

Details, Details

- Add a little bit of glitz with a pigment powder like Ranger's Perfect Pearls Pigments or Pearl Ex Pigment Powders. I especially recommend Perfect Pearls—when misted with water, Perfect Pearls will bind to each other and to your project surface. Their binding action prevents them from rubbing off.

- Pour UTEE over a folded piece of paper and transfer it back into the container so you can save any unused UTEE.

PAPER QUILTING

Quilting is one of those crafts I love but have never had the time to learn properly. So why not incorporate the simplest of quilting into the paper arts? With this technique, I married quilting and paper piecing to make playful embellishments. The paper towel layers add the puffiness needed to mimic the batting of a quilt. The machine stitching adds the perfect finishing touch.

HOME SWEET HOME WALL HANGING MATERIALS LIST

adhesives (*Scrapbook Adhesives by 3L, Stix2–kool tak*) • border (*Crate Paper*) • butterfly embellishments (*Jenni Bowlin*) • buttons (*BasicGrey*) • chipboard (*7gypsies, Maya Road, Sassafras*) • eyelets (*We R Memory Keepers*) • patterned paper (*Three Bugs in a Rug, 7gypsies, BasicGrey, Kaisercraft, October Afternoon, Studio Calico*) • pom-pom trim (*Maya Road*) • rhinestones (*Queen & Co.*) • ribbon • stickers (*Making Memories, Sassafras*) • tag (*7gypsies*) • tape (*7gypsies*)

WHAT YOU'LL NEED

Pencil
Chipboard shape
Paper towels
Scissors

Patterned paper
Sewing machine
Thread
Glue

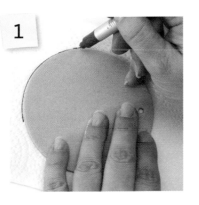

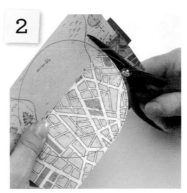

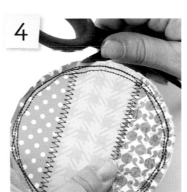

1 Trace a chipboard shape onto four layers of paper towel and cut out the shapes.

2 Trace around the chipboard shape onto patterned paper and cut out the shapes. If you trace onto the back of the patterned paper, you won't need to worry about pencil lines.

3 Sew layers of patterned paper and paper towels together.

4 Glue the sewn layers to the chipboard shape, and then fray the edges of the patterned paper and paper towels with scissors.

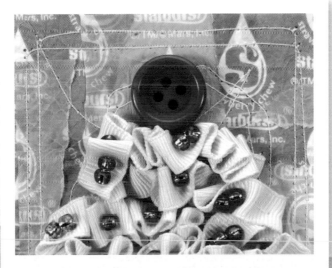

A Little Something Extra:
BATTINGLESS QUILTING

In this variation on the paper-quilting technique (see the With Lots of Love *card on page 112), I omitted the paper-towel "batting." The idea instead was to create a more patchworked or crazy-quilt look.*

STAMPED VELLUM

I love the semi-transparent quality of vellum. It appears to be rather delicate, but it is sturdier than it looks, and that makes it a perfect base for stamping. The quality of any color seems to be intensified when added to vellum, and as a result, vivid embellishments can be created. These little embellishments create a strong visual impact.

ALWAYS ENJOY TODAY LAYOUT MATERIALS LIST

adhesive (Scrapbook Adhesives by 3L) • chipboard (Making Memories) • ink (Ranger Industries) • metal circles (Making Memories) • paint (DecoArt) • patterned paper (Crate Paper; Sassafras) • stamps (Hero Arts) • stickers (KI Memories; Sassafras) • vellum (Michaels)

WHAT YOU'LL NEED

Rubber stamp

Vellum

Permanent or archival-quality
black ink pad

Heat gun

Acrylic paint

Paintbrush or foam brush

Distress Ink or dye-based ink pad

Foam sponge

Scissors

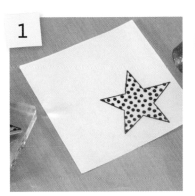

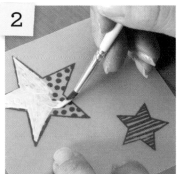

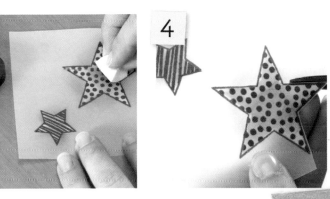

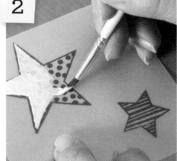

1 Stamp images onto a sheet
of vellum using permanent
black ink. Set the ink with a
heat gun.

2 Paint the back of the image
with acrylic paint and allow
the paint to dry.

3 Flip the vellum over and add
a small amount of dye ink
to the front of the stamped
image with a foam sponge.
Allow the ink to dry.

4 Cut the stamped images
from the vellum.

Details, Details

• Heat-set the stamped vellum immediately to prevent
the ink from bleeding.

• Adding the paint to the back of the image masks any
brushstrokes and tones down the amount of color that
shows through the front side of the vellum.

• You'll find another example of vellum embellishments in
the gallery piece Butterfly House on page 104.

TISSUE PAPER FLOWERS

And now, one final use for my favorite craft staple, tissue paper. I love the delicate, wispy look of tissue paper flowers. The light body quality of the tissue is perfect for crumpling and building lots of layers. The paper holds its shape beautifully, and it looks lovely with a light misting of color. These flowers will finish off your special project brilliantly.

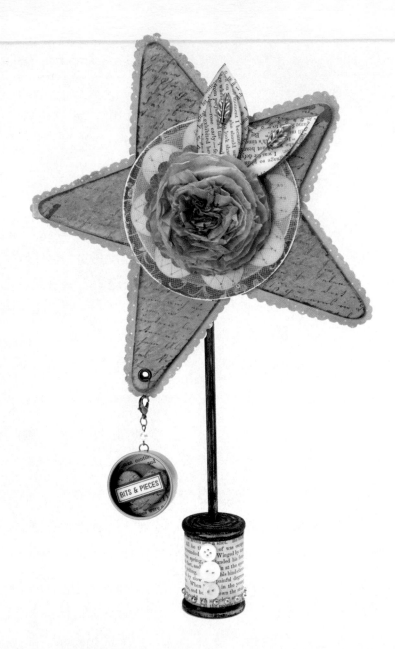

TISSUE PAPER FLOWER HOME DECOR MATERIALS LIST

adhesives *(Scrapbook Adhesives by 3L)* • brad *(7gypsies)* • charm *(7gypsies)* • chipboard *(7gypsies)* • die-cut flower *(Sassafras)* • eyelet *(We R Memory Keepers)* • ink *(Ranger Industries)* • patterned paper *(BasicGrey)* • pearls *(Queen & Co.)* • pins *(Maya Road)* • scalloped scissors *(Fiskars)* • spray ink *(Tattered Angels)* • stamp *(Hero Arts)* • sticker *(October Afternoon)* • tag *(7gypsies)* • buttons • tulle • wooden dowel • wooden spool

WHAT YOU'LL NEED

Large circle punch
Cardstock
Tissue paper
Scissors

Small hole punch or paper piercer
Decorative brad
Spray ink
Heat gun

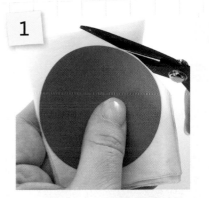

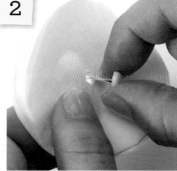

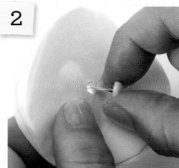

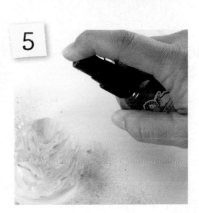

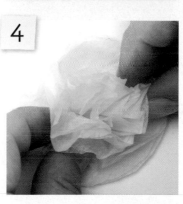

1. Punch a circle from cardstock for use as a template. Lay the circle template over five or six sheets of tissue paper and cut out circle shapes from the tissue.

2. Pierce or punch a hole through the circles. Attach a brad through the center of the layers of tissue-paper circles.

3. Gather the top layer of tissue and crumple it to form a flower.

4. Continue to crumple the layers until the flower takes shape.

5. Mist the tissue flower with spray ink.

6. Dry with a heat gun.

Details, Details

- Use crepe paper in place of tissue paper for a more textural effect on the flower.

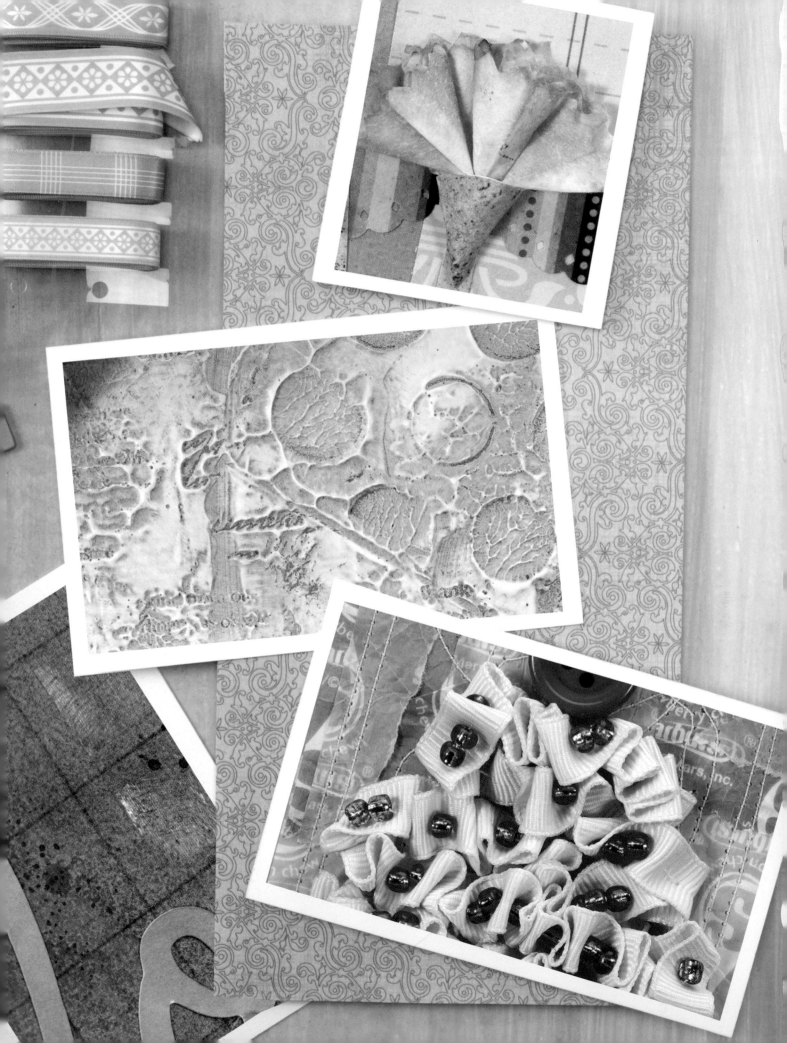

chapter five
LAYER IT ON!

It's all about the layers! The key is to break the collective whole into individual layers in order to figure out how it all works. That is, in essence, what we have been doing in the previous chapters. Each technique has been categorized and stepped out. Now that you know how to re-create the techniques, I am going to show you how to merge different techniques together to make pretty art.

When I teach my workshops, I always talk about layers. It's the way my mind understands how art works, and layering is really the main concept behind this whole book. In this gallery, I want to share more complex pieces. Think of them almost like recipes—I have taken techniques from various chapters and combined them into a single piece. While these techniques are great on their own, they are even better layered. The really groovy part is that you already know all my secrets because I shared them with you in the foundations, textures, supplements and embellishments chapters. Now when you look at the finished pieces, you will be able to see each layer, too.

I chose to include a few simple designs and some funky ones, too. I think it is interesting that even a very linear project can be multifaceted in its design. My tastes and influences are eclectic, and I think my art work is, too. Enjoy!

LIVE LAUGH LOVE

A canvas can be home to any number of fun techniques. I made a little flower garden with the cardstock flowers and rolled fabric flowers technique (made of both muslin and gaffer's tape). Gesso was layered over letter stickers to create a sticker mask, and bubble wrap helped create an interesting layered background.

1. Bubble Wrap (p. 10) + *2. Sticker Masking* (p. 70) + *3. Cardstock Flowers* (p. 78) + *4. Fabric Flowers* (p. 84) + *5. Gesso* (p. 44)

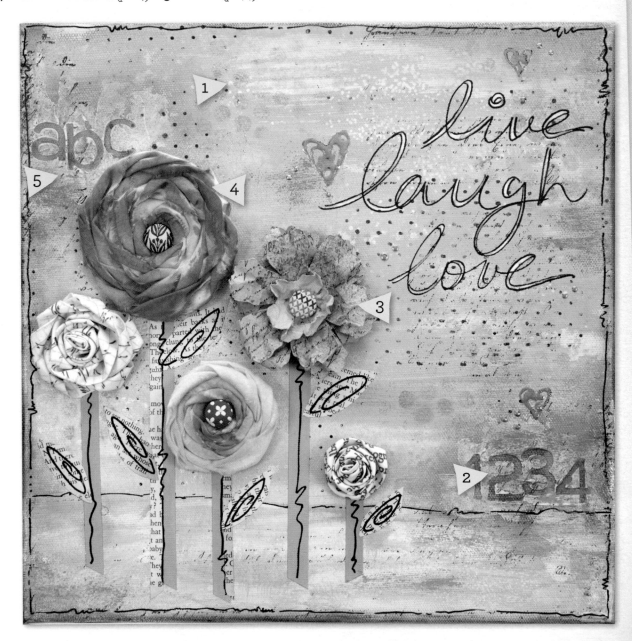

LIVE LOVE LAUGH CANVAS MATERIALS LIST

adhesive (*Beacon Adhesive*) • book paper • brads (*Sassafras*) • bubble wrap • canvas (*Canvas Concepts*) • cardstock (*Bazzill Basics*) • foil and foil adhesive (*Stix2–kool tak*) • gaffer's tape (*7gypsies*) • gesso (*DecoArt*) • glitter paint (*DecoArt*) • ink (*Ranger Industries*) • muslin • paint (*DecoArt*) • pen (*Sharpie*) • spray ink (*Tattered Angels*) • stamps (*Hero Arts*) • stickers for masks

LOVE TO LAUGH

Another great way to use the gel medium resist technique is with a mask, as seen on this layout, in which the grid pattern acts as a resist to Glimmer Mist and Distress Inks. The hearts are heat-embossed chipboard made with gold UTEE. Tissue paper was swapped out for coffee filters in creating the paper flowers.

1. Gel Medium Resist (p. 14) *+ 2. Heat Embossed Chipboard* (p. 88) *+ 3. Tissue Paper Flowers* (p. 94)

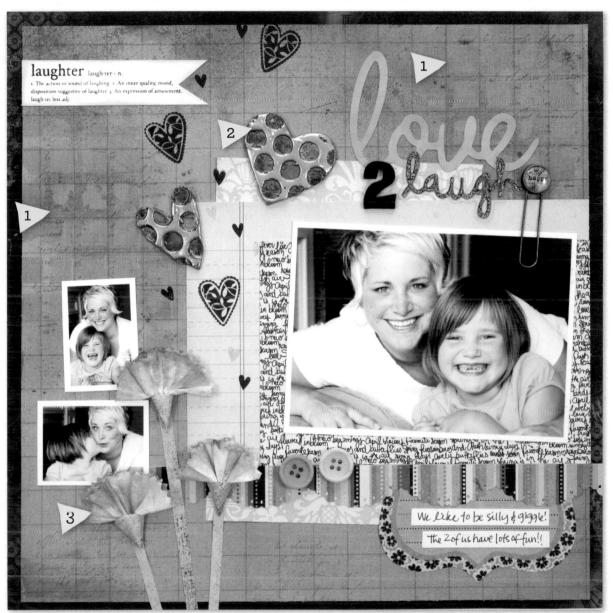

LOVE TO LAUGH LAYOUT MATERIALS LIST

adhesive (Scrapbook Adhesives by 3L) • button (Fancy Pants Designs) • chipboard (Stampin' Up!) • clip (GCD Studios) • die cut (Fancy Pants Designs) • embossing powder (Ranger Industries) • filter paper (Fancy Pants Designs) • foam letters (American Crafts) • gel medium (Ranger Industries) • grid template (The Crafter's Workshop) • inks (Ranger Industries) • love die cut (Making Memories) • medium pen (Ranger Industries) • patterned paper (BasicGrey, BoBunny Press, GCD Studios, Fancy Pants Designs) • pigment powder (Ranger Industries) • spray ink (Tattered Angels) • stamps (BasicGrey, Hero Arts, My Stamp Box, Stamping Bella) • transparent word (Fancy Pants Designs)

BRING ON THE HAPPY

The tree background stamp was the jumping-off point for this card. Alone it would be nice, but layering it with a great font, bubble wrap, glitter and paint brought out the wow factor! The star is a pre-made canvas piece that came to life with a little paint and glitter.

1. Bubble Wrap (p. 10) + *2. Embossed Resist* (p. 32) + *3. Fabric Painting* (p. 36) + *4. Glitter in Wet Paint* (p. 46)

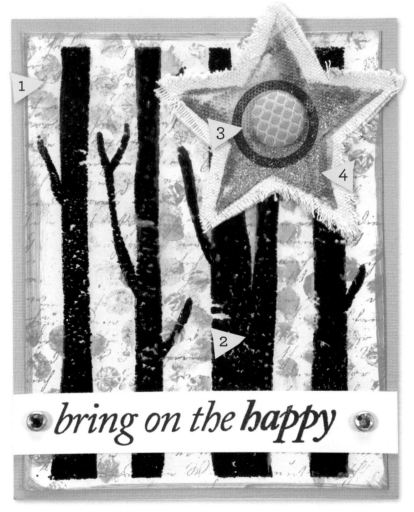

BRING ON THE HAPPY CARD MATERIALS LIST

brads (*American Crafts, BasicGrey*) • bubble wrap • canvas star (*Canvas Corp*) • cardstock (*Core'dinations*) • embossing ink and powder (*Ranger Industries*) • glitter (*DecoArt*) • inks (*Ranger Industries*) • paint (*DecoArt*) • stamps (*Hero Arts*)

LOVELY DOLLY

I love Kewpie dolls! So when I found this one at a friend's art store, along with a not-so-pretty gold frame filled with pressed flowers, I knew I would find something to do with these little treasures. I love how this project turned out! The magazine paper covered the ugly frame perfectly, the bubble wrap with glitter sprinkled on the wet paint adds a nice backdrop and the cupcake wrapper skirt finished off the doll.

1. Bubble Wrap (p. 10) + *2. Magazine Collage* (p. 16) + *3. Glitter in Wet Paint* (p. 46) + *4. Cupcake Wrapper Flowers* (p. 80)

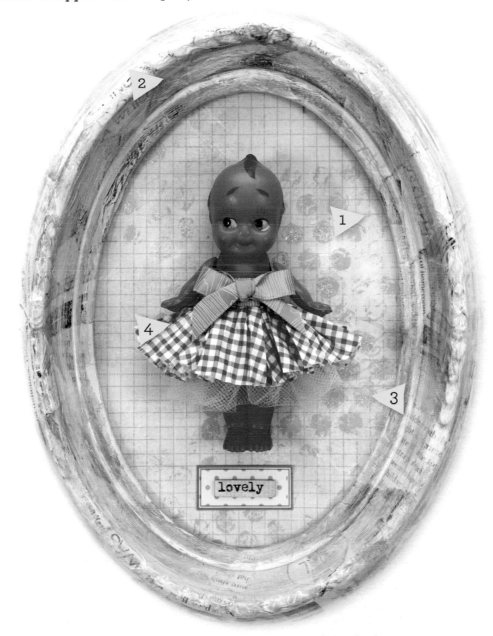

LOVELY DOLLY FRAME MATERIALS LIST

adhesive (*Beacon Adhesives, Scrapbook Adhesives by 3L*) • chipboard (*GCD Studios*) • cupcake wrappers • frame • gel medium (*Ranger Industries*) • glitter (*DecoArt*) • magazine papers • metallic paint (*Viva Decor*) • paint (*DecoArt*) • patterned paper (*Pink Paislee*) • plastic doll • ribbon (*American Crafts*) • sticker (*Jenni Bowlin*) • tulle

LET'S SNUGGLE

There are lots of techniques peeking in and out on this layout. I blended frottaged leaves with negative masking. The cupcake wrapper flowers and glitter tape are peeking out of the punched circles. And the border on the bottom of the page was created with stamps and crayon resist. It may seem like a lot, but they all work together harmoniously.

1. Negative Mask (p. 22) + *2. Crayon Resist* (p. 12) + *3. Frottage* (p. 42) + *4. Glitter Tape* (p. 62) + *5. Cupcake Wrapper Flowers* (p. 80)

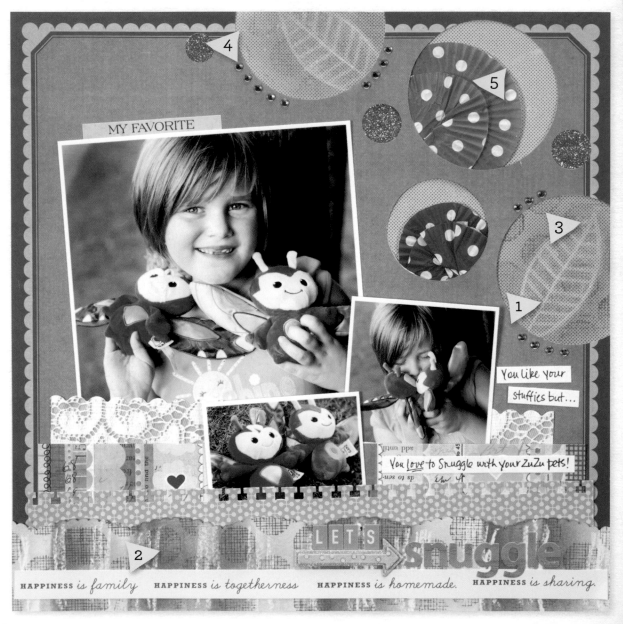

LET'S SNUGGLE LAYOUT MATERIALS LIST

adhesive *(Scrapbook Adhesives By 3L)* • border *(Cosmo Cricket)* • crayon *(Crayola)* • gems *(Queen & Co.)* • glitter *(In the Making Enterprises)* • ink *(Ranger Industries)* • paper punches *(EK Success, Fiskars)* • patterned paper *(Cosmo Cricket, October Afternoon, Sassafras)* • stamps *(Hero Arts)* • stickers *(K&Company, October Afternoon, Sassafras, The Girls' Paperie)* • cupcake wrappers • packing tape

CHERISH ENJOY

I love how the tissue paper decoupage technique works with the painted layer beneath! The tissue adds a gauzy finish to the painterly floral print. The glitter tape circles add the perfect finishing touch.

1. Tissue Paper Decoupage *(p. 50)* **+ 2. Glitter Tape** *(p. 62)*

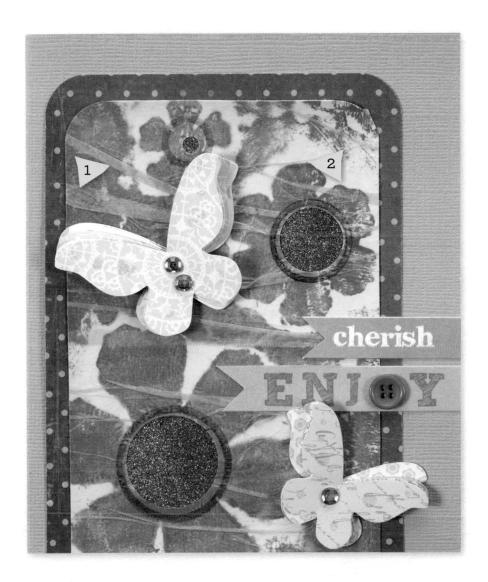

CHERISH ENJOY CARD MATERIALS LIST

butterflies *(Little Yellow Bicycle)* • cardstock *(Core'dinations)* • die-cut template *(Sizzix)* • gel medium *(Ranger Industries)* • gems *(Queen & Co.)* • glitter *(In the Making Enterprises)* • ink *(Hero Arts)* • paper punches *(Fiskars; EK Success)* • patterned paper *(Crate Paper)* • stamps *(Gel-A-Tins)* • stickers *(Little Yellow Bicycle)* • tissue paper

BUTTERFLY HOUSE

Tissue paper decoupage is a great way to add a bit of texture to a photo frame. The spots of stamped gesso add both visual and tactile interest. A way to take the stamped vellum embellishments up a notch is by layering them together to create a 3-D effect. The faux letterpress mats created the perfect backdrop for the vellum butterflies.

1. Faux Letterpress (p. 40) + *2. Gesso* (p. 44) + *3. Tissue Paper Decoupage* (p. 50) + *4. Stamped Vellum* (p. 92)

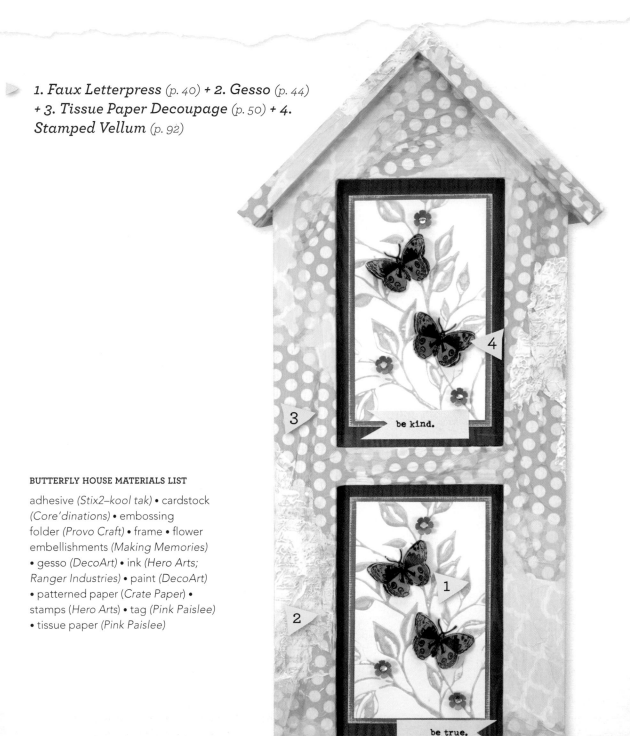

BUTTERFLY HOUSE MATERIALS LIST

adhesive *(Stix2–kool tak)* • cardstock *(Core'dinations)* • embossing folder *(Provo Craft)* • frame • flower embellishments *(Making Memories)* • gesso *(DecoArt)* • ink *(Hero Arts; Ranger Industries)* • paint *(DecoArt)* • patterned paper *(Crate Paper)* • stamps *(Hero Arts)* • tag *(Pink Paislee)* • tissue paper *(Pink Paislee)*

A GOOD AFTERNOON

The encased and tie-dye markers techniques work well together. They are both very textural, and the materials available for either present an almost endless color selection. The crayon resist allows the white from the base cardstock to shine through.

▶ *1. Crayon Resist* (p. 12) + *2. Encased* (p. 34) + *3. Tie-Dye Markers* (p. 48)

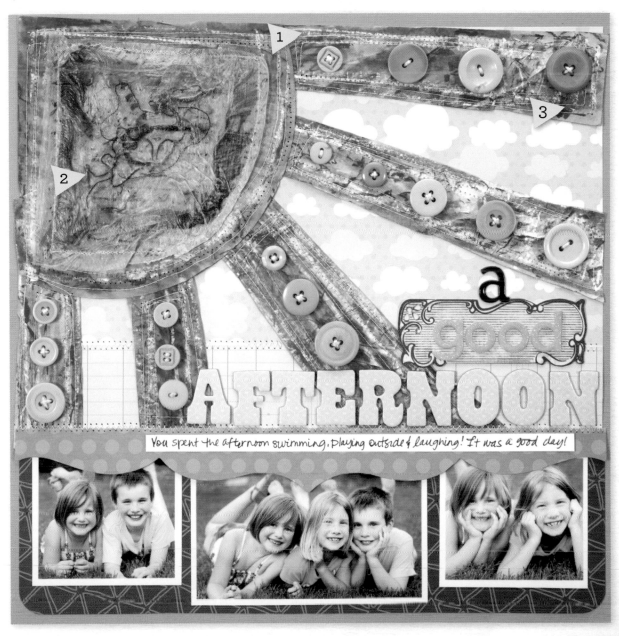

A GOOD AFTERNOON LAYOUT MATERIALS LIST

adhesive (*Scrapbook Adhesives By 3L*) • cardstock (*Core'dinations*) • chipboard letters (*American Crafts*) • border (*My Little Shoebox*) • crayon (*Crayola*) • fibers (*BasicGrey*) • gel medium (*Ranger Industries*) • ink (*Ranger Industries*) • markers (*Crayola*) • patterned paper (*American Crafts, My Little Shoebox*) • pen (*American Crafts*) • stamps (*Hero Arts*) • stickers (*My Little Shoebox*) • tag (*K&Company*) • tissue paper

4YOU

The butterfly shape for this card is actually the "negative" shape from the butterflies I had die cut for the foil transfer technique (see pages 86–87). Remember . . . think before you trash it! The inside of the butterfly image combines negative masking, embossed resist, bubble wrap and glitter in wet paint. I used a glazing liquid with the bubble wrap instead of paint and to that I added the glitter.

1. Bubble Wrap (p. 10) + *2. Negative Mask* (p. 22) + *3. Embossed Resist* (p. 32) +
4. Glitter in Wet Paint (p. 46)

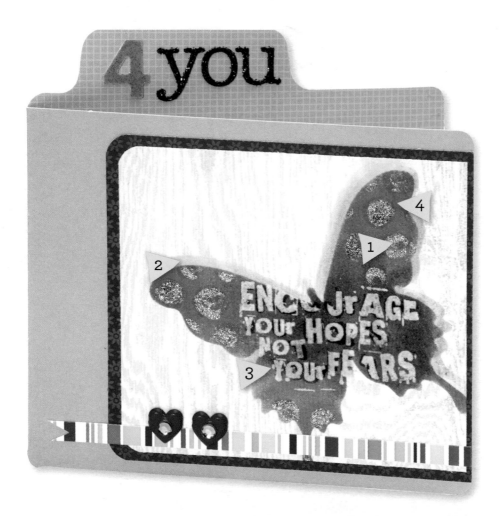

4YOU CARD MATERIALS LIST

brads (*Doodlebug Design*) • card (*Doodlebug Design*) • die-cutting machine (*Silhouette*) • embossing ink and powder (*Ranger Industries*) • glitter (*In the Making Enterprises*) • glazing medium (*DecoArt*) • ink (*Ranger Industries*) • patterned paper (*BasicGrey, Doodlebug Design*) • stamp (*Stampers Anonymous*) • stickers (*Doodlebug Design, Sassafras, Pink Paislee*)

BIRD HOUSE SHADOW BOX

I like to create art that makes people want to touch it and figure out how it was made. The texture from the gesso and stamps forms an appealing backdrop for the stamped bird, while the masking tape adds another textural component to the frame. It is simple but effective.

1. Gesso (p. 44) *+ 2. Masking Tape* (p.64)

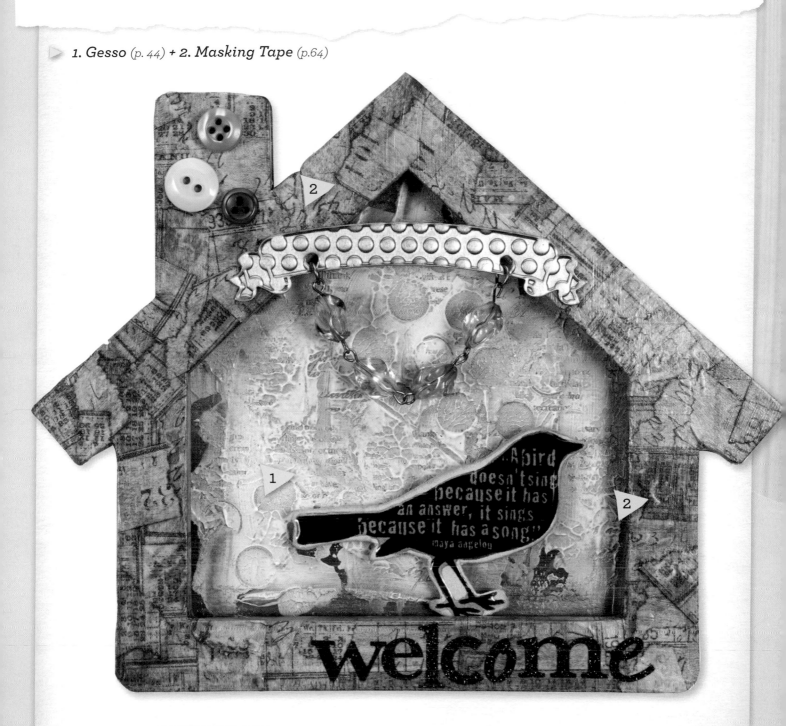

BIRD HOUSE SHADOW BOX MATERIALS LIST

adhesive (Ranger Industries) • beaded dangle (7gypsies) • buttons (Foofala) • gesso (DecoArt) • house shape (Darcie's) • ink (Ranger Industries) • metal label(Pink Paislee) • metallic paint (Viva Decor) • paper tape (Tim Holtz idea ology) • spray ink (Ranger Industries) • stamps (Hero Arts, Fiskars) • stickers (Making Memories)

THAT A BOY

Piecing different colors and shapes of paper towel art together can make for a great look, and adding machine stitching helps bind the pieces together. The white glue stamped circles help ground the punched paper circles.

▶ *1. Paper Towel Art* (p. 68) + *2. White Glue Stamp* (p. 72)

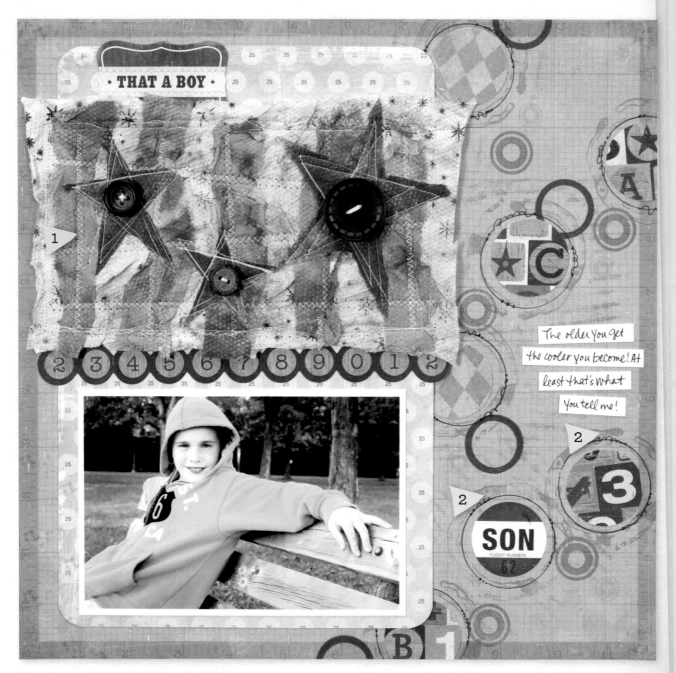

THAT A BOY LAYOUT MATERIALS LIST

adhesive *(Scrapbook Adhesives by 3L)* • buttons *(Crate Paper)* • cardboard • ink *(Hero Arts, Ranger Industries)* • paper punches *(Fiskars)* • paper towels • patterned paper *(Crate Paper)* • pen *(American Crafts)* • spray ink *(Tattered Angels)* • stamps *(Hero Arts, My Stamp Box)* • stickers *(Crate Paper)* • white glue

THANKS MONOGRAM

For a different approach, I used a colored metal tape for the embossed metal technique on the chipboard letter. Once the chipboard was embossed and sanded, I added two shades of alcohol inks to the exposed metal.

▷ *1. Paper Piecing* (p. 66) + *2. Embossed Metal Chipboard* (p. 82) + *3. Tissue Paper Flower* (p. 94)

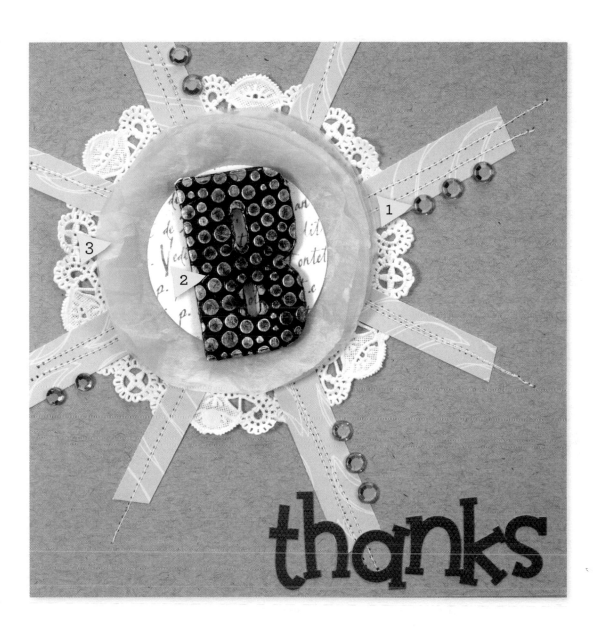

THANKS MONOGRAM CARD MATERIALS LIST

adhesive (*Stix2–kool tak*) • alcohol ink (*Ranger Industries*) • cardstock (*Bazzill Basics*) • chipboard (*Pink Paislee*) • doily (*Wilton*) • embossing folder (*Provo Craft*) • gems (*Queen & Co.*) • metal tape (*TENSeconds Studio*) • paper punch (*Fiskars*) • patterned paper (*American Crafts, BasicGrey*) • sandpaper • stickers (*Doodlebug Design*) • tissue paper

FOUND HEART

To be honest, I had tried another technique on this boxed canvas, and I didn't like it. I decided to give it another go with the burnished metal technique on the box portion, and I covered the canvas with vintage book pages. The chipboard under the foil added interest to the plain box, and the book paper covered the "oops" I had made on the canvas. The heart was created from wire, and I stretched the encased-in-tissue-paper technique across it.

1. Encased (p. 34) + *2. Burnished Metal* (p. 54) + *3. Magazine Collage* (p. 16)

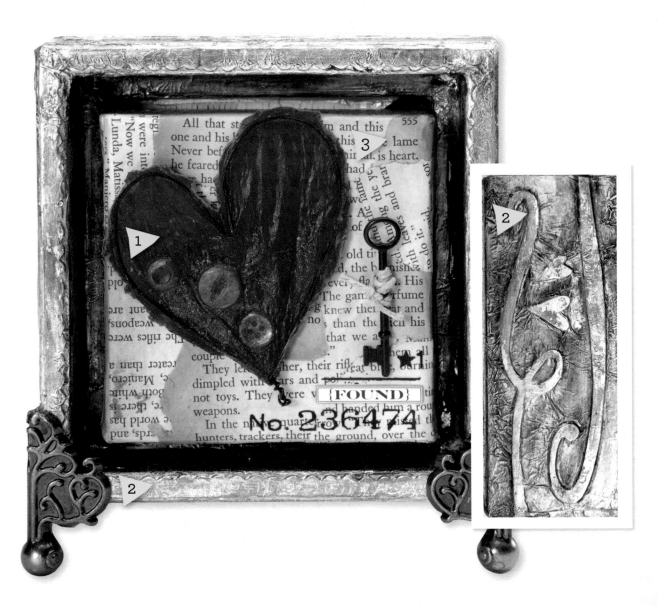

FOUND HEART CANVAS BOX MATERIALS LIST

adhesive *(Stix2–kool tak)* • aluminum foil • book paper • boxed canvas • buttons • chipboard *(7gypsies, Maya Road)* • decorative metal legs *(Tim Holtz idea-ology)* • gel medium *(Ranger Industries)* • glitter *(In the Making Enterprises)* • ink *(Ranger Industries)* • key *(7gypsies)* • metallic paint *(Viva Decor)* • paint *(DecoArt)* • rub-ons *(7gypsies)* • sealer *(DecoArt)* • sticker *(7gypsies)* • tissue paper • twine • wire *(Darice)*

PARIS

I love the versatility of using craft foam to make stamps. The decorative border on this layout was created using a large sheet of foam. The gathered dryer sheets provide a pretty little ruffle, and the scalloped circle features a wax paper resist and stamping.

1. Wax Paper Resist (p. 28) **+** *2. Dryer Sheet Art* (p. 58) **+** *3. Foam Stamps* (p. 60)

PARIS LAYOUT MATERIALS LIST

adhesives (*Scrapbook Adhesives by 3L, Stix2–kool tak*) • chipboard (*American Crafts*) • craft foam • die cuts (*Pink Paislee*) • ink (*Ranger Industries*) • paper punches (*Fiskars, Marvy Uchida*) • patterned paper (*American Crafts, My Little Shoebox, Pink Paislee*) • spray ink (*Tattered Angels*) • stamps (*Hero Arts*) • used dryer sheets

WITH LOTS OF LOVE

When the beads are threaded onto ribbon, the ribbon has a tendency to ruffle and gather when the thread is pulled, which makes for the perfect "icing" for a cupcake! To sweeten up this card even more, I added a quilted candy wrapper background. The key is to place the wrappers between two sheets of scrap paper and iron them to remove the wax. I used the cupcake wrappers fairly literally for the base of the cupcake.

1. Candy Wrapper Decoupage (p. 56) + *2. Paper Quilting* (p. 90) + *3. Beaded Ribbon Ruffle* (p. 76) + *4. Cupcake Wrapper Flowers* (p.80)

WITH LOTS OF LOVE CARD MATERIALS LIST

adhesives *(Scrapbook Adhesives by 3L, Stix2–kool tak)* • beads *(Hirschberg Schutz & Co.)* • button • candy wrappers • card *(Doodlebug Design)* • ribbon *(Michaels)* • sticker *(Little Yellow Bicycle)* • thread

HOME

Canvas is a great base for the smooshing technique because the paint does not readily absorb into the canvas, and therefore allows movement of the paint when the plastic wrap is applied. Once the plastic wrap was removed, I used a wet paintbrush to remove the paint inside the clouds; the crayon that outlined the clouds and canvas border also resisted the paint. Three paper-pieced houses finish off this canvas nicely.

1. Crayon Resist (p. 12) + *2. Reverse Resist* (p. 24) + *3. Smooshing* (p. 26) + *4. Paper Piecing* (p. 66)

HOME CANVAS MATERIALS LIST

adhesive (*Scrapbook Adhesives by 3L*) • canvas • cardstock (*Core'dinations*) • chipboard (*Maya Road, Stampin' Up!*) • crayon (*Crayola*) • metallic paint (*DecoArt*) • paint (*DecoArt*) • paper punch (*Fiskars*) • patterned paper (*Pink Paislee*) • pen (*American Crafts*) • plastic wrap

THE MULBERRY TREE

Leanin' up in the forks, I can see the old rail,
And the boy climbin' up it, claw, tooth, and toe-nail,
And in fancy can hear, as he spits on his hands,
The ring of his laugh and the rip of his pants.
But that rail led to glory, as certin and shore
As I'll never climb thare by that rout' any more—
That was all the green lauruls of Fame unto me,
With my brows in the boughs of the mulberry tree!

Its who can fergit the old mulberry tree
As knowed in the days when his thoughts was as free
As the flutterin' wings of the birds that flew out
Through the wavin' tops as the boys come about?
Tall crowd of my memories, laughin' and gay,
A-climbin' the fence of that pastur' to-day,
And a-pantin' with joy, as us boys ust to be,
They go racin' acrost fer the mulberry tree.

30

114

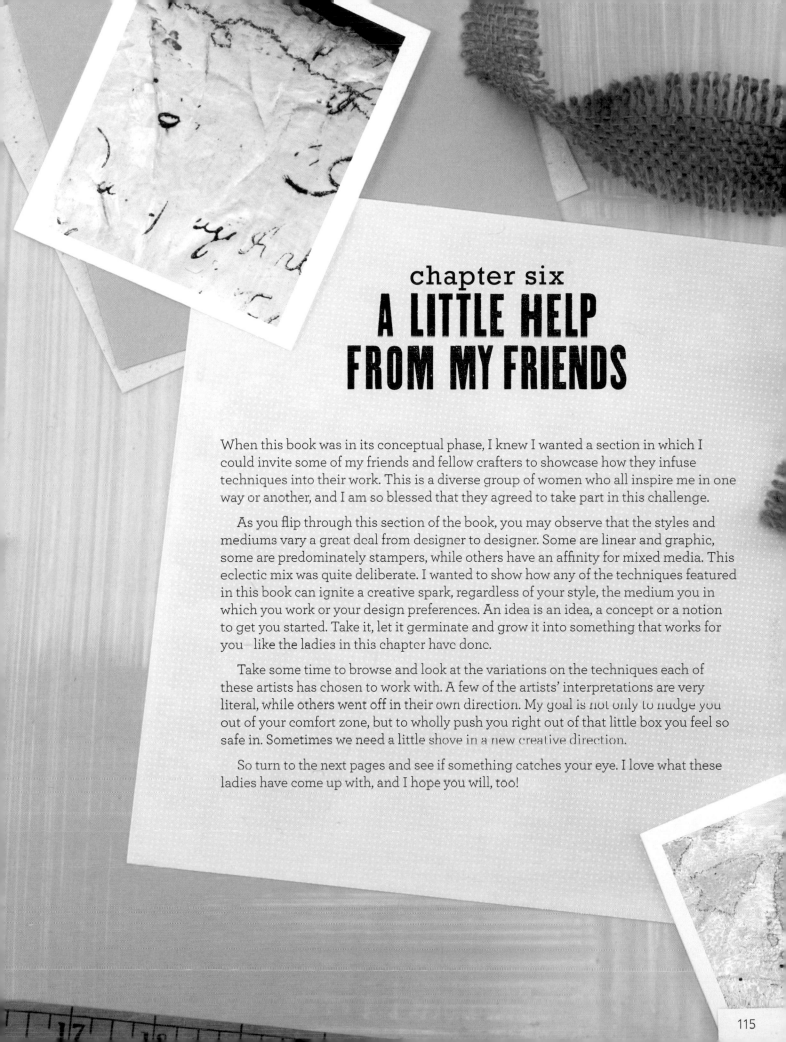

chapter six
A LITTLE HELP
FROM MY FRIENDS

When this book was in its conceptual phase, I knew I wanted a section in which I could invite some of my friends and fellow crafters to showcase how they infuse techniques into their work. This is a diverse group of women who all inspire me in one way or another, and I am so blessed that they agreed to take part in this challenge.

As you flip through this section of the book, you may observe that the styles and mediums vary a great deal from designer to designer. Some are linear and graphic, some are predominately stampers, while others have an affinity for mixed media. This eclectic mix was quite deliberate. I wanted to show how any of the techniques featured in this book can ignite a creative spark, regardless of your style, the medium you in which you work or your design preferences. An idea is an idea, a concept or a notion to get you started. Take it, let it germinate and grow it into something that works for you like the ladies in this chapter have done.

Take some time to browse and look at the variations on the techniques each of these artists has chosen to work with. A few of the artists' interpretations are very literal, while others went off in their own direction. My goal is not only to nudge you out of your comfort zone, but to wholly push you right out of that little box you feel so safe in. Sometimes we need a little shove in a new creative direction.

So turn to the next pages and see if something catches your eye. I love what these ladies have come up with, and I hope you will, too!

MY GIRLS

By Bethany Kartchner

I am a huge technique junkie; I collect technique books like some people collect charms. In my mind, there is nothing more exciting than learning a new technique and adapting it to my personal style. Combining multiple techniques in one piece adds interest and makes creating art so much fun!

For this wall hanging (mounted on wood), I did the beaded ribbon ruffle technique, and I did the tissue paper decoupage technique on the background. I covered the entire panel with gesso and then painted over that. I added water-soluble oil pastels to the edges. I made the flowers using the cupcake wrapper technique, gluing buttons in the centers and threading wire through the buttons. The heart is chipboard decoupaged with magazine pages and painted red. The photos are mounted on cardstock.

1. Magazine Collage (p. 16) + 2. Tissue Paper Decoupage (p. 50) + 3. Beaded Ribbon Ruffle (p. 76) + 4. Cupcake Wrapper Flowers (p. 80) + 5. Gesso (p. 44)

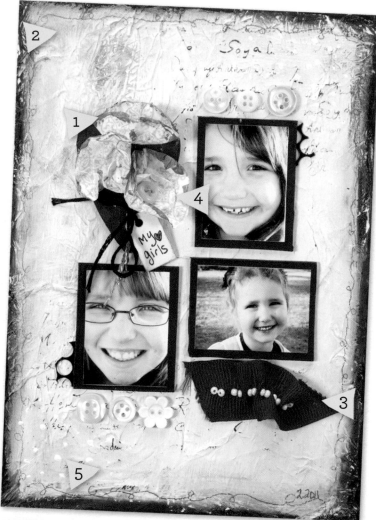

MY GIRLS WALL HANGING MATERIALS LIST

adhesive (*DecoArt*) • buttons • cardstock (*Bazzill*) • chipboard (*Bazzill*) • cupcake wrappers • embroidery floss (*DMC*) • gesso (*DecoArt*) • ink (*StazOn*) • paints (*DecoArt*) • paper punches (*McGill*) • pen (*Sharpie*) • pencil • punchinella • ribbon (*upcycled from a gift package*) • scrap wood panel • seed beads • stamps (*JudiKins*) • tissue paper • water-soluble oil pastels • wire

LOVE AT HOME ALTERED HOUSE

By Rhonna Farrer

I have a degree in art education and enjoyed teaching children how to create art for many years. Even though I have evolved into a graphic artist and I now design on a computer, I still enjoy getting back to my roots in art. I love getting messy with paints and different art mediums. When Vicki invited me to join in on techniques, I knew right away which techniques would inspire me as I worked on these art projects.

Mixed-media techniques always inspire me. I love using modeling paste, and here I used a negative reverse technique using the scroll pattern; once the scroll mask was in place, I applied the modeling paste around the scroll so it would give that negative look. After the paste dried, I burnished it with Distress Ink to highlight the raised negative pattern.

1. Bubble Wrap (p. 10) + *2. Gel Medium Resist* (p. 14) + *3. Smooshing* (p. 26)

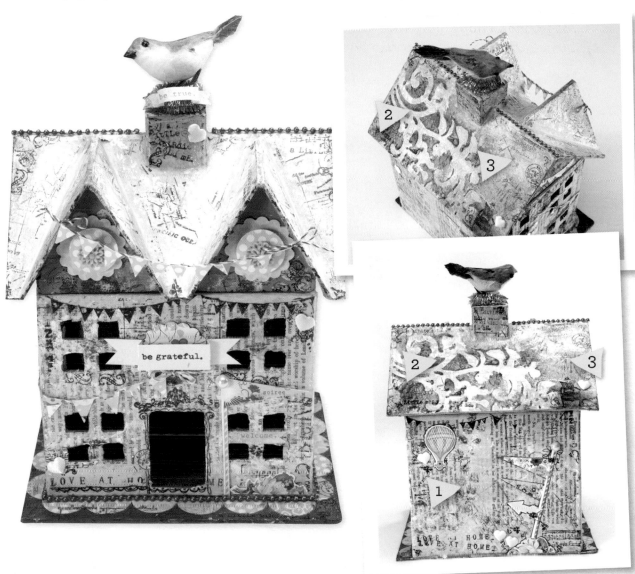

LOVE AT HOME ALTERED HOUSE MATERIALS LIST

acrylic paints • beaded edging • bird embellishment • bubble wrap • doilies • gel medium (*Mod Podge*) • inks and spray inks (*Ranger Industries, StazOn, Tattered Angels*) • modeling paste • papier mâché house form • patterned papers, flags, balloon, arrow, words (*Pink Paislee*) • pipe cleaner • plastic • resin flowers (*Bazzill*) • stamps (*Pink Paislee*) • stencil (*Tattered Angels*) • twine (*Pink Paislee*) • vintage book pages

BUTTERFLY SHADOW BOX

By Linda Albrecht

To create this Butterfly Shadow Box, I used Vicki's burnished metal and magazine collage techniques. For the burnished metal background, I applied lines with hot glue, burnished around them and then distressed over them with brown glaze. The butterflies were made by decoupaging magazine bits over chipboard shapes. Then I painted over the decoupaged butterflies with two coats of gesso, and when the second coat was almost dry, I used a wide straight-edge putty knife to scrape off some of the gesso and expose the magazine images and words. Finally, I added paint and several coats of decoupage medium to bulk up the butterflies.

▷ *1. Magazine Collage* (p. 16) *+ 2. Burnished Metal* (p. 54)

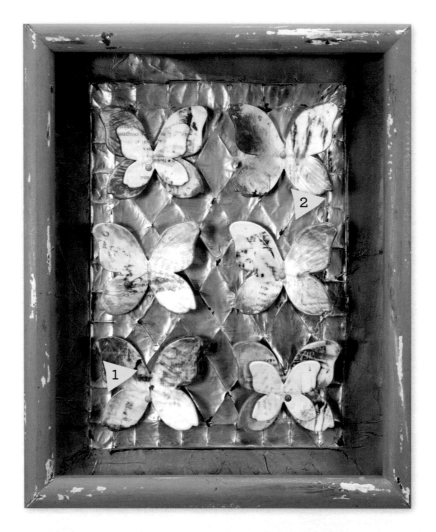

BUTTERFLY SHADOW BOX MATERIALS LIST

acrylic paint (*Folk Art*) • aluminum foil • chipboard • decoupage medium (*Mod Podge*) • die cuts (*AccuCut*) • glaze • hot glue • stick pins • white gesso (*Demco*) • wood shadow box

LITTLE MISS SUNSHINE

By Jennifer Perks

I really liked how Vicki's techniques can be layered together to create a variety of looks. I often use paper piecing on my layouts; however, I had never thought to add dimension to the pieces by quilting them like I did with the cloud here. It made for a fresh approach to an old standard, which I loved!

One thing to note about the white glue stamp technique I used: You know that saying about necessity being the mother of invention? Well, I didn't have white glue on hand (I know, weird for someone with young children in the house, right?), so I thought I'd use a hot-glue gun instead. Lo and behold, it worked! And talk about instant gratification . . . the stamp was ready to go within minutes.

1. Reverse Resist (p. 24) + *2. Paper Piecing* (p. 66) + *3. White Glue Stamp* (p. 72) +
4. Beaded Ribbon Ruffle (p. 76) + *5. Paper Quilting* (p. 90)

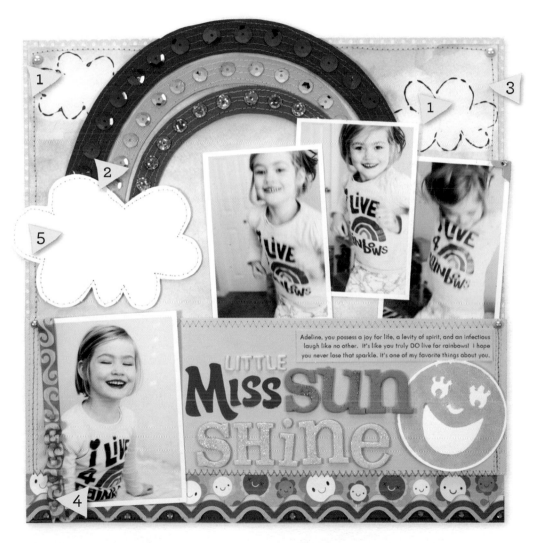

LITTLE MISS SUNSHINE LAYOUT MATERIALS LIST

adhesive (EK Success, 3M, Tombow) • beads (Westrim Crafts) • cardstock (Bazzill Basics, Kaisercraft, Prism, Stampin' Up!) • chipboard (Heidi Swapp) • embossing folder and die-cutting machine (Provo Craft) • font (AL Uncle Charles, downloaded from the Internet) • glitter (Art Institute Glitter) • paints (Making Memories, Plaid) • patterned paper (Sassafras) • pearls and rhinestones (Queen & Co.) • photo corner (Heidi Swapp) • ribbon (KI Memories) • sequins • stamp (Alex Toys) • stickers (American Crafts, Sandylion) • thread (Coats & Clark) • watercolor paper (Strathmore)

SMILE AND THANKS CARDS

By Jennifer McGuire

I find great joy in creating crafty projects! Cool and innovative techniques are the icing on the cake, so when Vicki asked me to whip up a few projects for her book, it was right up my alley. I love to challenge myself by seeing how many techniques I can pile onto a project, and I had a great time layering them on my favorite medium . . . cards!

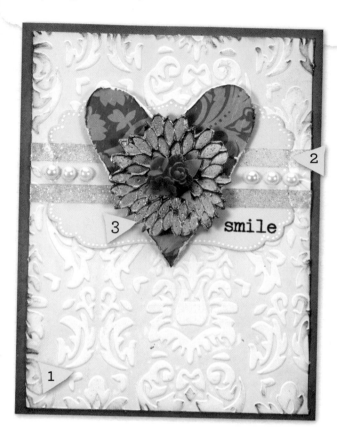

For this card, I combined a faux letterpress background with glitter tape strips I made from packing tape. To create the flower detail, I used the embossed chipboard technique, but I swapped paper for the chipboard and stamped a flower image in layers of silver embossing powder.

▶ *1. Faux Letterpress* (p. 40) *+ 2. Glitter Tape* (p. 62) *+ 3. Heat-Embossed Chipboard* (p. 88)

SMILE CARD MATERIALS LIST

embossing folder *(Sizzix)* • embossing powder *(Ranger Industries)* • glitter *(Hero Arts)* • ink *(Hero Arts, Ranger Industries, Tsukineko)* • label die *(My Favorite Things)* • packing tape • notecard *(Hero Arts)* • pearls *(Hero Arts)* • pen *(Uni-ball)* • stamps *(Hero Arts)*

For this card, I ran glossy paper through an embossing folder and then colored the raised areas with a white crayon in a frottage technique. I love the messy look! I also created cardstock flowers with a pearl finish and completed the look with heat embossed vellum leaves.

▶ *1. Crayon Resist* (p. 12) *+ 2. Embossed Resist* (p. 32) *+ 3. Cardstock Flowers* (p. 78) *+ 4. Stamped Vellum* (p. 92)

THANKS CARD MATERIALS LIST

cardstock *(Bazzill)* • crayon • dies *(My Favorite Things)* • embossing folder *(Sizzix)* • embossing powder *(Hero Arts)* • gemstones *(Hero Arts)* • glossy paper *(Ranger Industries)* • ink *(Ranger Industries; Tsukineko)* • pigment powder *(Ranger Industries)* • stamps *(Hero Arts)* • vellum

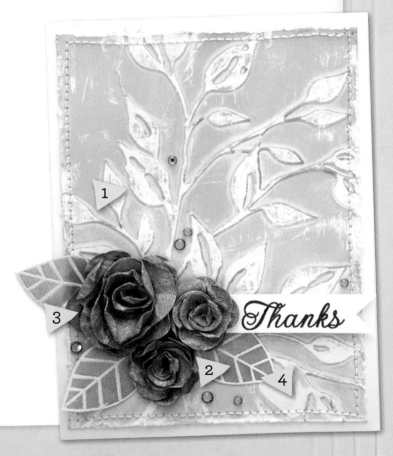

SWEET GIRLS

By Greta Hammond

Although I am typically a self-proclaimed lazy scrapper, there are times when I want to incorporate techniques into my projects! While I do love to occasionally add a technique here and there to make my projects pop, I tend to keep them confined to an embellishment or border in order to fit into my linear style. I loved having the opportunity to play with some of the techniques Vicki outlined in this book, and I couldn't wait to try the cupcake wrapper and tissue paper flowers as well as the tissue paper decoupage (see page 128). All the techniques I used were incredibly simple (for a lazy scrapper like me!) but produced amazing results. I had a ton of fun just playing around!

1. Crayon Resist (p. 12) + 2. Embossed Resist (p. 32) + 3. Tissue Paper Flowers (p. 94)

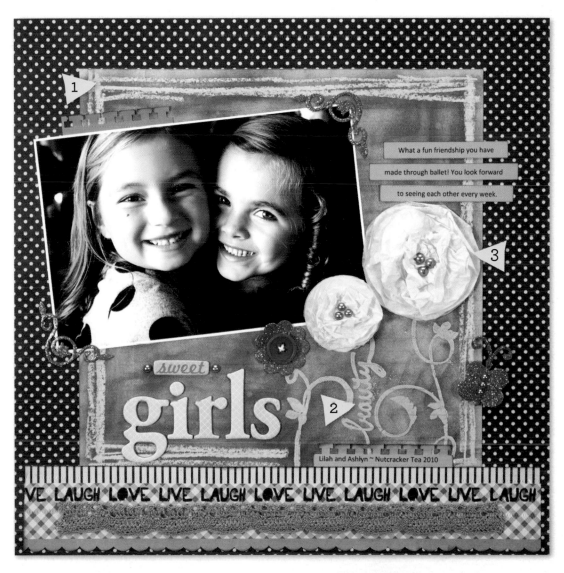

SWEET GIRLS LAYOUT MATERIALS LIST

adhesive *(Fancy Pants Designs)* • buttons *(Fancy Pants Designs)* • cardstock *(Bazzill, Worldwin Papers)* • chipboard *(American Crafts)* • die-cutting machine *(Provo Craft)* • embossing powder *(Ranger Industries)* • filter papers *(Fancy Pants Designs)* • glitter *(Doodlebug Design)* • ink *(Ranger Industries)* • notebook border punch • patterned paper *(Fancy Pants Designs)* • pearls *(Queen & Co.)* • ribbon *(Fancy Pants Designs)* • spray ink *(Tattered Angels)* • stamps *(Fancy Pants Designs)* • tissue paper

THANK YOU CARD

By Melissa Phillips

For this card, I layered on the techniques, beginning with the die-cut vellum scallops. One layer was kept plain and simple, while the top layer was coated with spray adhesive and glitter. Next came the die-cut leaves, which I stamped with painted bubble wrap. I love the subtle distressing it added. The ruffled and scrunched seam binding came next, with pearl beads woven into the ruffles—such a fun technique and it added a perfect touch of whimsy. Lastly, I made rolled fabric flowers with tea-stained muslin. They are simple but added a bit of drama to top off this fun card.

▷ *1. Bubble Wrap* (p. 10) + *2. Glitter Tape* (p. 62) + *3. Beaded Ribbon Ruffle* (p. 76) + *4. Fabric Flowers* (p. 84) + *5. Stamped Vellum* (p. 92)

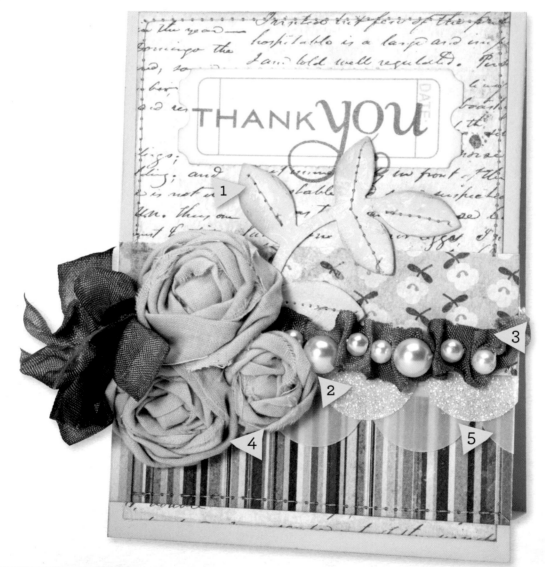

THANK YOU CARD MATERIALS LIST

adhesive *(Beacon)* • cardstock *(Papertrey Ink)* • die cuts *(My Mind's Eye)* • ink *(Papertrey Ink)* • muslin • paints *(Delta)* • paper punches *(Papertrey Ink)* • patterned paper *(My Mind's Eye)* • pearl beads • ribbon *(memriemare.etsy.com)* • stamps *(Papertrey Ink)* • vellum *(Papertrey Ink)*

EMBRACE AND TWO HEARTS

By Wendy Vecchi

When Vicki invited me to make art for her book, she mentioned my favorite word—techniques. I wanted to create multi-layered dimensional pieces of art using techniques that focus on stamping. By combining several products, you have the option to create many different looks each time you use them.

Grab your stamps and inks and then choose your surface. Remember . . . stamping isn't only for paper! Ready, set, make art! I hope you have fun; I sure did.

1. Gesso *(p. 44)* + 2. *Embossed Metal Chipboard* (p. 82)

EMBRACE THE POSSIBILITIES MATERIALS LIST

adhesive, color wash, ink, paint *(Ranger Industries)* • art base, art film, stamps *(Studio 490/Stampers Anonymous)* • book paper • die cuts *(Sizzix)* • gesso *(Ranger Industries)* • grunge board, clip, trimming *(Tim Holtz idea-ology)* • thread lace • vintage buttons

1. *Masked Background* (p. 18) + 2. *Cardstock Flowers* (p. 78)

TWO HEARTS ONE LOVE MATERIALS LIST

adhesive, ink, color wash, stain *(Ranger Industries)* • art base, art film, stamps *(Studio 490/Stampers Anonymous)* • buttons, fasteners, grunge paper, patterned paper *(Tim Holtz idea-ology)* • handcut heart stencil • pencil • sequin waste • sewing machine • stencil *(Stampers Anonymous)*

LOTS OF LOVE AND FEEL BETTER CARDS

By Danielle Flanders

I always love trying new techniques in my work, which keeps scrapbooking fun, fresh and exciting for me! I chose to work with cardstock flowers and tissue paper flowers, as my style is a little more feminine, and my piles of patterned papers and cardstock abound. I found it fun to put everyday products to great use. I also really adored the negative masking and faux letterpress techniques, both of which opened up more options for me in creating with my collection of stamps and dies.

▷ *1. Faux Letterpress* (p. 40) *+ 2. Tissue Paper Flowers* (p. 94)

SENDING YOU LOTS OF LOVE CARD MATERIALS LIST

chalk *(Stampin' Up!)* • die cuts *(Papertrey Ink, Tiny Tags Designs)* • embossing plate *(Papertrey Ink)* • ink *(Papertrey Ink, Tsukineko)* • patterned paper *(Pink Paislee)* • ribbon *(Papertrey Ink)* • stamp *(Papertrey Ink)* • tissue paper streamers *(Target)* • thread • white cardstock

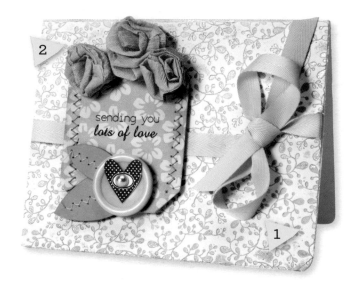

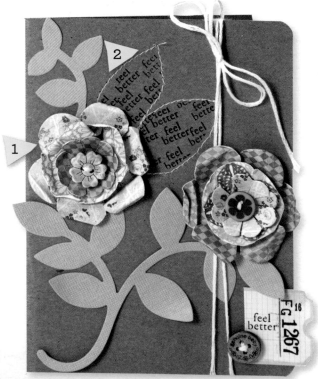

▷ *1. Cardstock Flowers* (p. 78) *+ 2. Negative Mask* (p. 22)

FEEL BETTER CARD MATERIALS LIST

buttons *(Crate Paper)* • cardstock *(Papertrey Ink)* • die cuts *(Papertrey Ink)* • floss *(DMC)* • ink *(Papertrey Ink)* • patterned papers *(Crate Paper)* • sentiment *(Papertrey Ink)* • ticket *(Pink Paislee)*

BIRD KING

By Bethany Kartchner

In this piece, I tissue paper decoupaged the top of the canvas. I placed a strip of decorative tape along the right side about an inch from the edge. I stamped circles into wet gesso to make the circles on the top left. I drew a bird onto a piece of cardstock, covered it with candy wrapper decoupage (Rolos!) and colored it with Ranger Alcohol Inks in Stream and Butterscotch. I punched the flowers out of magazine pages and painted them with Americana's Emperor's Gold paint and glued seed beads into the centers. I attached the stick with embroidery floss. I cut words out of a magazine to make the "heart art." I punched the circles out of a magazine and glued them down and then glued buttons on top. I handsewed beads to the pom-pom ribbon. I added more interest by stenciling in the bottom left and top right corners. I outlined everything with a pencil. The edges of the piece were filled in with oil pastels.

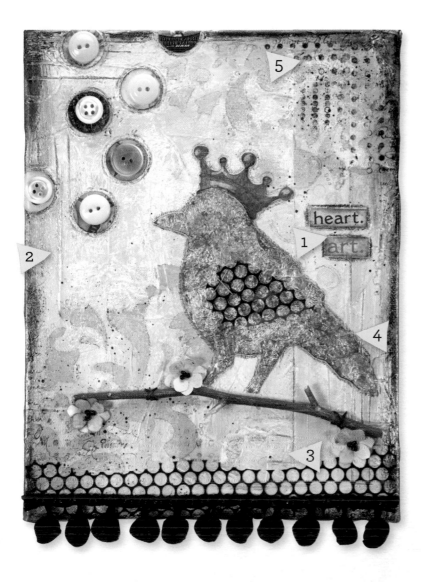

1. Magazine Collage (p. 16) + *2. Gesso* (p. 44) + *3. Tissue Paper Decoupage* (p. 50) + *4. Candy Wrapper Decoupage* (p. 56) + *5. Masking Tape* (p. 64)

BIRD KING WALL HANGING MATERIALS LIST

adhesive (*DecoArt*) • alcohol inks (*Ranger Industries*) • buttons • cardstock (*Bazzill*) • decorative tape • embroidery floss (*DMC*) • gesso (*DecoArt*) • ink (*StazOn*) • magazine pages • paints (*DecoArt*) • paper punches (*Creative Memories, Martha Stewart*) • pencil • punchinella • ribbon • Rolo candy wrappers • seed beads • small stick (*for perch*) • stamps (*dots: Hero Arts, script: JudiKins, crown: My Mind's Eye*) • stencil template (*The Crafter's Workshop*) • tissue paper • water-soluble oil pastels

SLIP-ON BOOK COVER

By Linda Albrecht

For the Slip-On Book Cover, I used the following techniques:

Fabric painting: I painted the book cover and the three ruffled fabric pieces. I tore lightweight muslin into strips and color washed them. When they were completely dry, I used a sewing machine to gather the fabric into ruffles and then glued the ruffles to the book cover.

Tissue paper flowers: I cut flower shapes from dressmakers' tissue using a die-cutting machine. I cut lots of layers, and I stitched the layers together and then fluffed them out and sprayed them with Glimmer Mist.

1. Fabric Painting (p. 36) + *2. Tissue Paper Flowers* (p. 94)

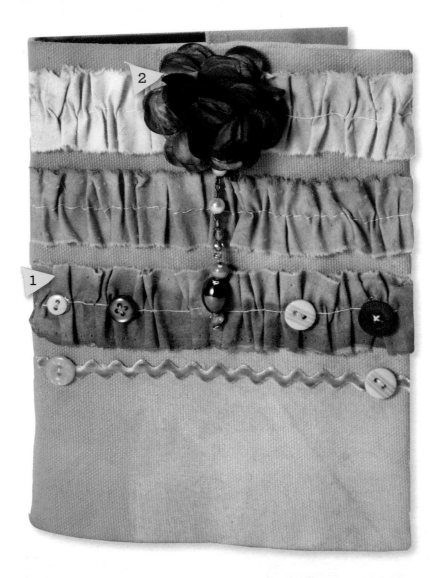

SLIP-ON BOOK COVER MATERIALS LIST

20-gauge silver wire • acrylic paints *(Folk Art)* • beads *(The Bead Gallery)* • buttons *(BasicGrey)* • cotton canvas fabric • dressmakers' tissue • flower die-cuts *(AccuCut)* • lightweight unbleached muslin fabric • spray ink *(Tattered Angels)* • velvet rickrack *(BasicGrey)*

THIS IS MY STREET AND UROCK CARD

By Kelly Purkey

I had so much fun playing with Vicki's cool techniques. All her ideas got me to try something new. I've been on a color mist kick lately, so I wanted to tackle some of her great misting ideas. Blending colors together is one of my favorite things to do, so I enjoyed playing around with punches and all the fun mist colors in my collections. I love that I was able to combine my simple, clean style with some artsy techniques from Vicki.

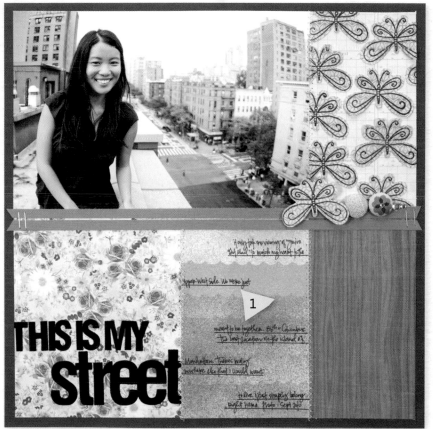

1. Masked Background (p. 18)

THIS IS MY STREET LAYOUT MATERIALS LIST

brads (Crate Paper) • cardstock (American Crafts) • gems • ink (StazOn) • paper punches (Fiskars) • patterned paper (Crate Paper, American Crafts) • pen (American Crafts) • spray ink (Studio Calico) • staples • stamps (Hero Arts) • stickers (American Crafts)

1. Negative Mask (p. 22) + 2. Candy Wrapper Decoupage (p. 56)

UROCK CARD MATERIALS LIST

candy wrappers • cardstock (American Crafts) • gems; paper punch (Fiskars) • pen (American Crafts) • pinking sheers • spray ink (Studio Calico) • stickers (American Crafts)

BIRTHDAY TRAY

By Greta Hammond

Because the sections in my Birthday Tray were already well defined, I took the opportunity to play with some of the techniques that Vicki outlines in her book, while still keeping to my linear style. I used several techniques, including tissue paper decoupage, sticker resist and wax paper resist, to create different backgrounds for the sections. I couldn't wait to try the cupcake wrapper flower, and I also loved how the tissue paper decoupage looked on my butterfly. All of the techniques I used were incredibly simple (for a lazy scrapper like me!) but produced amazing results. I had a ton of fun just playing around!

1. Tissue Paper Decoupage (p. 50) + *2. Cupcake Wrapper Flower* (p. 80) +
3. Sticker Masking (p. 70) + *4. Wax Paper Resist* (p. 38)

BIRTHDAY TRAY MATERIALS LIST

adhesive (*Mod Podge, Tombow*) • chipboard (*Jenni Bowlin*) • cupcake wrappers • die cuts (*Pink Paislee*) • dimensional stickers (*Pink Paislee*) • gems (*Pink Paislee*) • ink (*Ranger Industries; Tattered Angels*) • pearls (*Queen & Co.*) • patterned paper (*Pink Paislee*) • pearls (*Queen & Co.*) • ribbon • stamps (*Hero Arts*) • stickers (*BasicGrey; Scenic Route*) • tissue paper (*Pink Paislee*) • twine (*Pink Paislee*) • wood embellishments (*Pink Paislee*) • wax paper

BELIEVE YOU WILL FLY

By Jennifer Perks

The monoprint technique really pushed me outside my "box." There was a lot more paint involved than I would usually use, not to mention that I had less control over the end result! As I pulled the Plexiglas off the canvas, I didn't know what to expect. I was delighted with what I saw! This piece was effortlessly artsy, which is not something I usually associate with my work or my process.

1. Monoprint (p. 20) + *2. Tie-Dye Markers* (p. 48) + *3. Glitter Tape* (p. 62)

BELIEVE YOU WILL FLY CANVAS MATERIALS LIST

adhesive (*Tombow*) • cardstock (*Stampin Up!*) • chipboard (*Making Memories*) • die cuts (*QuicKutz*) • die-cutting machine (*Cuttlebug*) • font (*Love Letter TW, downloaded from Internet*) • glitter (*Art Institute Glitter, Making Memories, Martha Stewart*) • glue gun • markers (*Crayola*) • packing tape (*3M*) • paints (*DecoArt, Delta Creative, Plaid, Krylon, Making Memories*) • paper punches (*EK Success*) • stickers (*Sassafras*)

FABRIC FLOWER STATEMENT NECKLACE
By Rhonna Farrer

Fabric flowers and ruffles are my loves! I enjoy experimenting with all techniques to create new looks. One of my favorite tools and techniques is printable fabric. So I printed out one of my trellis designs on the fabric, created a ruffle and attached it to the necklace. I used Glimmer Mist to mist the ribbon and flowers for some color and wow. And I used a "singed" flower technique to add some visual interest.

1. Fabric Painting (p. 36) + *2. Fabric Flowers* (p. 84)

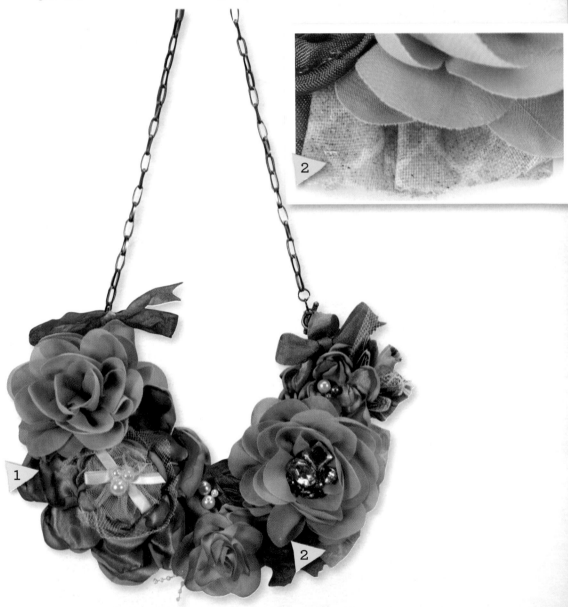

FABRIC FLOWER STATEMENT NECKLACE MATERIALS LIST

fabric • feathers • fabric flowers *(Pink Paislee)* • felt • gem brads *(Pink Paislee)* • ink *(Tattered Angels)* • necklace chain/findings *(Tim Holtz Idea-ology)* • pearls • printable fabric *(Pelon)* • ribbon • trellis pattern download *(Pink Paislee)* • tulle

TURNER, MY BOY LAYOUT AND LOVE YOU CARD

By Kelly Goree

While I have been scrapbooking in some form or another for as long as I can remember and have tried a variety of styles and techniques over the years, I have now found myself comfortably in my "box." Working with Vicki on this book forced me to try things that I never would have attempted on my own. The techniques I tried are wonderful for building texture and pattern without adding dimension. I am amazed at how fun, easy (and yes, *messy*!) it all is, and now I'm excited to take something new with me into my "box!"

1. Masked Background (p. 18) + 2. Embossed Resist (p. 32) + 3. Stamped Vellum (p. 92)

TURNER, MY BOY LAYOUT MATERIALS LIST

Adhesive (3M; American Crafts,Scrapbook Adhesives by 3L) • brads • cardstock (Prism) • die cuts • embossing powder (Ranger Industries) • ink (Tsukineko) • paper punches (EK Success, Martha Stewart, Marvy Uchida) • patterned paper (My Mind's Eye) • pens (Uni-ball, Zig) • spray ink (Maya Road) • stamps (Hero Arts) • stickers (BasicGrey) • vellum (Grafix)

1. Embossed Resist (p. 32) + 2. Stamped Vellum (p. 92)

LOVE YOU TO PIECES CARD MATERIALS LIST

adhesive (3M, American Crafts, Scrapbook Adhesives by 3L) • cardstock (Bazzill Basics) • embossing powder (American Crafts) • embroidery floss (DMC) • ink (Clearsnap,Tsukineko) • paper punch (Marvy Uchida) • patterned paper (My Mind's Eye) • pens (Uni-ball) • stamp marker (American Crafts) • stamps (Close to My Heart, Hero Arts) • vellum (Grafix)

ART QUILT AND EMBROIDERY HOOP PROJECT

By Lucy Edson

Creating a whole cloth-painted quilt on canvas gives you complete freedom of expression. I went with an art-journal-style quilt—adding in a favorite quote to go along with the butterflies. Layers and layers of paint and masking create a complex background with very little effort.

▷ *1. Masked Background* (p. 18) + *2. Fabric Painting* (p. 36) + *3. Glitter in Wet Paint* (p. 46) + *4. Paper Quilting* (p. 90)

BUTTERFLY ART QUILT MATERIALS LIST

adhesive *(DecoArt)* • batting • butterfly template *(Vinnie Pearce)* • canvas • felt • gesso *(DecoArt)* • glitter • ink *(Ranger Industries, StazOn)* • paper punches *(Martha Stewart)* • marker *(Sharpie)* • stamp • thread

▷ *1. Masked Background* (p. 18) + *2. Fabric Painting* (p. 36)

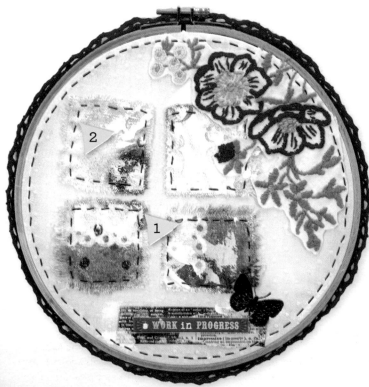

Mixing up layers and mediums is one of my favorite things. I love the effect of paint and collage on fabric. By layering paints and masking over canvas, the small torn squares provide tiny bits of art to decorate my vintage-inspired embroidery. This mix of vintage and modern creates an interesting look.

EMBROIDERY HOOP PROJECT MATERIALS LIST

adhesive *(DecoArt)* • canvas • chipboard *(GCD Studios)* • cotton dotted swiss • crochet trim • embroidery hoop • gaffer's tape *(7gypsies)* • ink *(StazOn)* • paints *(DecoArt, Ranger Industries)* • paper punches *(Martha Stewart)* • stamps *(Stampington & Company, Stampin' Up!)* • vintage dictionary page • vintage tea towel

VELLUM POCKET CARD

By Melissa Phillips

For this project, I created a pocket from vellum by simply folding a block of it in half and stitching it up the sides and across the bottom. I stitched on a top layer of cream tulle first and then slipped in a die-cut doily to create a double pocket of sorts. The base of the chipboard heart in the bottom left corner was made by covering it with metal duct tape, running it through my embossing machine, painting it with acrylic paint and then accenting the embossing with a Copic marker. The small tag attached to the larger tag uses another fun technique that involved coating my embossing plate with ink and then running the tag through my machine so the ink was transferred onto both the tag and the embossed pattern. Finally, the aqua flowers were created from a dryer sheet cut into strips, folded in half, gathered into a ruffle by running it through my sewing machine, and then winding it into a flower. I added Glimmer Mist at the last minute to give the flowers some color.

1. Faux Letterpress (p. 40) + **2. Dryer Sheet Art** (p. 58) + **3. Embossed Metal Chipboard** (p. 82) + **4. Fabric Flowers** (p. 84)

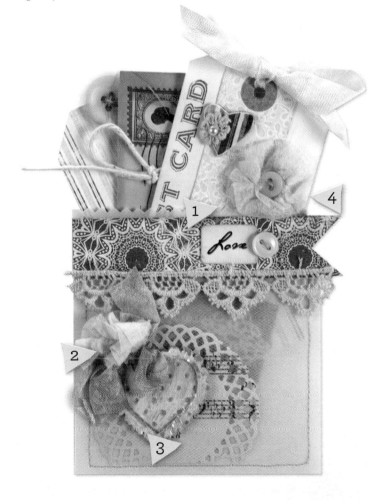

VELLUM POCKET CARD MATERIALS LIST

adhesive (*Beacon Adhesives*) • buttons (*Papertrey Ink*) • chipboard (*Maya Road*) • dryer sheets • enclosure (*Papertrey Ink*) • glitter (*Martha Stewart*) • ink (*American Crafts, Papertrey Ink, Tattered Angels*) • marker (*Copic*) • metal duct tape • paints (*Delta Creative*) • paper punches (*Fiskars, Papertrey Ink*) • patterned paper (*My Mind's Eye*) • ribbon (*www.memriemare.etsy.com*) • stamps (*Papertrey Ink*) • tags (*Avery, Melissa Frances*) • trim (*Prima Marketing*) • tulle, vellum (*Papertrey Ink*) • vintage sheet music

About the Contributors

LINDA ALBRECHT

Hi, I'm Linda Albrecht, a scrapbooker and longtime arts-and-crafts enthusiast from Minnesota. I've lived in Minnesota my entire life, and my children and extended family are close by. I can't imagine living anywhere other than in a small town. I love its character and am always inspired by its simplicity. I grew up in a creative atmosphere that included everything from sewing and stitchery to painting and photography. Those things are still a part of how I create. I am inspired by anything with a history and an aged patina, and I find it easy to replicate that Shabby Chic distressed look (just my style!) with paint and color mists. Just like old painted and chipped furniture that shares the story of its years, I want my projects to have depth and warmth that are layered with stories of their own.

To see what I'm currently working on, visit my blog, http://lindaalbrecht.typepad.com.

LUCY EDSON

It seems like I have been crafty all my life and have always loved color. I have been creating mixed media for about six years. I have also sewn, and dabbled with stained glass, painting and quilting. I enjoy teaching techniques and sharing ideas, including sharing my video tutorials online. Combining techniques from other crafts into my scrapbooking projects is a fun challenge for me and gives me the opportunity to combine all my favorite things: fabric, photos, paint and stitching.

I live in a small town in northern Florida with my husband and daughter and enjoy going to the beach and rivers. My family is first with me, and I love sharing my life with them.

This hobby has certainly changed my life more than I ever imagined. The wonderful friendships and sharing community have presented many great opportunities, and I've been able to share my designs and my love for being creative. I'm currently a guest artist for Stampington and have been fortunate to be a frequent contributor to Somerset publications with my artwork and tutorials. You can learn more at http://lucyscraftylife.blogspot.com.

RHONNA FARRER

Family + Art + Teaching: This unique combination is what I enjoy most about creating. I'm a wife and the mother of three young children, so there's never any shortage of inspiration or creative material. As a designer in the greeting cards and gift industry, digital and hybrid scrapbooking/crafting was a logical evolution for me. In 2004, I won the *Creating Keepsakes* Hall of Fame competition. I spent two years working as creative director for *Digital Scrapbooking* magazine, four years at Two Peas in a Bucket as a "garden girl" and lead digital designer, and two years with House of Three. Currently I am a part of the Wacom Pen Scrappers team. In addition to my career as an artist, I have a degree in art education and have taught both nationally and internationally. I'd love for you to visit my blog, http://rhonnadesigns.com.

DANIELLE FLANDERS

Danielle Flanders has been scrapbooking for eleven years. She began when her first daughter was born, in order to create a baby album for her. Since then, Danielle's articles and designs have been published in numerous magazines and e-books. Danielle currently works for several scrapbooking manufacturers, including Pink Paislee, Melissa Frances, Jenni Bowlin, Crate Paper and Papertrey Ink, and she has taught at scrapbooking events and trade shows around the country. Formerly an elementary school teacher, Danielle is now a stay-at-home mother to two daughters, ages 11 and 5, and resides in upstate New York. Perhaps as a result of having two girls, her style is very feminine, colorful and creative, and she loves to try new techniques and find inventive uses for products. When Danielle's not scrapbooking, she enjoys quilting, painting, organizing and hanging out with her family. Visit her blog to see more of her work: www.danielleflanders.blogspot.com.

KELLY GOREE

Kelly Goree lives in the beautiful horse country of Kentucky with her husband of thirteen years and her three rambunctious boys. She was introduced to scrapbooking in early 2000

just after her oldest son was born, and it quickly became a favorite hobby, and shortly thereafter, an all-out passion. She'll tell you that if she's not out chasing her boys, you can find her scrapping!

Kelly is a full-time staff designer and instructor for BasicGrey, where she is a driving force in designing

work for classes, trade shows, catalogs and special events. In 2006 she earned the honor of being named a *Memory Makers* Master. Kelly has more than 500 published works, many of which can be found in the pages of *Creating Keepsakes*, *Better Homes & Garden's Scrapbooks Etc.*, *Scrapbook Trends*, *Paper Trends*, *Scrapbooking & Beyond* and other scrapbooking and paper arts publications and books. Visit Kelly's blog to see more of her work: http://kellygoree.blogspot.com/.

GRETA HAMMOND

Greta Hammond's real creative passion began when she discovered scrapbooking about ten years ago, after her son was born. The outlet scrapbooking provided was just what she needed after deciding to stay home with her son. Greta has since shared her love of scrapbooking by teaching at local scrapbooking stores, and has the privilege of doing freelance work with a number of industry manufacturers and magazines. She was thrilled to have been chosen a *Memory Makers* Master in 2007 and inducted into the *Creating Keepsakes* Hall of Fame in 2006. Greta has been published in numerous magazines and idea books, and she coauthored an idea book in August 2009. When she's not creating, she is spending time with her husband and two children at their home in northern Indiana.

BETHANY KARTCHNER

Bethany Kartchner is a much-published mixed-media memory artist. Her work has appeared in *Somerset Memories*, *Somerset Studio*, *GreenCraft*, *Somerset Apprentice*, *Creating Keepsakes*, *Scrapbook Trends*, *Paper Crafts* and *Art Quilting Studio*. Her work has appeared on the cover of *GreenCraft* and *Somerset Apprentice*. Bethany's artwork has also been on exhibit at Buell Children's Museum in Pueblo, Colorado. She currently enjoys teaching online classes and creating video tutorials.

Bethany resides in Phoenix, Arizona, with her husband and six children: three boys and three girls, ages five months to nine years. She has a passion for books, science, hot chocolate, sock monkeys, Holly Hobbie, spumoni ice cream, buttons, vintage lace and everything French. She can be found furiously creating in her studio during naptimes and after bedtimes.

You can get to know Bethany better via her blog: www.creativeruminations.com.

JENNIFER MCGUIRE

Jennifer, a *Creating Keepsakes* Hall of Famer, has been scrapbooking and stamping since about 2002. Her creations have been featured in countless publications, including numerous magazines and books. Jennifer is well known for her column in *Creating Keepsakes* magazine, "Tools & Techniques," in which she demonstrates the many things you can do with one tool or product. She has written two *Creating Keepsakes* books based on these articles, *101 Things To Do With Your Scrapbook Supplies* and *101 More Things To Do With Your Scrapbook Supplies*.

An avid stamper, Jennifer has been an artist for Hero Arts for the past seven years. She also serves as an education director for Hero Arts, creating online video tutorials and traveling the world teaching stamping classes.

Jennifer is also Ranger and Copic certified, and she frequently contributes designs to Tim Holtz and Ranger Industries and enjoys sharing her designs and more on her blog, www.jennifermcguireink.com. Jennifer lives in Cincinnati, Ohio, with her husband, Ken, stepdaughters, Kay and Audrey, and son, Colin. She blogs at www.jennifermcguireink.com.

JENNIFER PERKS

Jennifer Perks began scrapbooking shortly after the birth of her second child almost six years ago. Since then she has been a 2007 *Creating Keepsakes* Hall of Famer and a member of the 2008 and 2009 *Better Homes & Gardens Scrapbooks Etc.* creative teams.

Jennifer has had numerous designs published in both *Creating Keepsakes* and *Scrapbooks Etc.* magazines and idea books and several other publications. She has also designed for Chatterbox and Queen & Co.

Jennifer lives in Round Rock, Texas, with her husband and their three children, Eleanor, William, and Adeline. During the day she is employed as a speech-language pathologist in a middle-school setting. Scrapbooking provides her a much-needed creative outlet that she enjoys because it combines her love of family, photography, color and design while serving a purpose—the preservation of those fleeting moments she'd probably otherwise forget.

MELISSA PHILLIPS

Hi, my name is Melissa Phillips. I live with my husband and little girl in southern Nevada. Looking back, I think I have always had a love for paper, glitter and glue—these things have fascinated me since I was little, but I didn't give myself the time needed to explore this hobby until I graduated from college. It seemed that at that time my ducks were in a row and I was ready to do something for myself, so I started making thank-you notes to send out after my little girl arrived. I was enchanted and my love for paper-crafting has continued to grow.

My work has been published in *Scrapbook Trends*, *Paper Trends*, *Simply Handmade*, *Artful Blogging*, *Creating Keepsakes*, *Scrapbooks Etc.*, and *Paper Crafts* magazine.

Sharing my love of cardmaking and papercrafting with others is one of my favorite things to do—getting others excited about creating what their hearts desire and enjoying the process as they go along is the most rewarding part of this journey for me.

You can keep up with the latest through my blog, http://lilybeanpaperie.typepad.com/lilybeans_paperie.

KELLY PURKEY

As a single girl, Kelly often gets asked what she scrapbooks about. To ensure she always has a good answer to this question, Kelly enjoys filling her life with wonderful friends, amazing adventures and travels, life in the big city and lots of delicious food, all of which create excellent photo opportunities for her to scrap.

Kelly lives on the island of Manhattan in New York City, which is a dream come true for her. She works from home for Studio Calico as a freelance scrapbooker and product designer, but is often flying around the country to teach classes or dip her toes in the ocean. Kelly has worked as a product designer at American Crafts, was a member of the 2008 and 2009 *Creating Keepsakes* Dream teams, has contributed to a variety of publications and is an instructor at *Creating Keepsakes* Conventions.

Kelly loves photo booths, the Brooklyn Bridge, art museums, stamps in her passport and impromptu dance parties.

You can live vicariously through Kelly at http://kellypurkey.typepad.com.

WENDY VECCHI

Wendy Vecchi is a full-time artist and designer, senior educator for Ranger, and a past member of the Tim Holtz and Maya Road design teams. Wendy loves to demo and teach at stores and events across the country, and has been published in numerous publications. She was the guest instructor for the Artful Voyage in Mexico with Tim Holtz in October of 2009. Wendy has her own signature line of stamps from Stampers Anonymous titled Studio 490, and she also recently introduced her signature Art Parts, which are simply . . . parts to make art. Her style is unique and eclectic with an exceptional attention to detail and a fresh approach to the creative spirit. She released her fourth idea book, *Make Art, Studio 490 Style*, at CHA in January 2011. She shares her love of techniques on her blog and reminds you that whatever you do each day, just "Make Art!" You can find more inspiration on Wendy's blog, studio490art.blogspot.com.

About the Author

Vicki Boutin comes from a background in graphic design and fine arts and has always been passionate about creating pretty things. Her love of color, texture, funky patterns and photography led her to scrapbooking and paper crafting. She has not looked back since!

In 2006, Vicki became a *Creating Keepsakes* Hall of Fame winner and went on to be part of *Better Homes and Gardens Scrapbooks Etc.*'s creative team. Her work is currently published in *Scrapbooks Etc.*, and Vicki writes a quarterly article for *Scrapbooks & Cards Today* magazine. She enjoys working closely with a number of the industry's top manufacturers, including Sassafras, 7gypsies, Basic-Grey, Little Yellow Bicycle and Pink Paislee. Vicki is also a Ranger certified instructor.

Vicki is always on a mission to learn something new and then find a way to share it. That is where teaching comes in! She has taught workshops in the United States, Canada and Europe and loves to approach art in a fun, fresh and accessible way. Her motto is "You don't know if it's your style until you try it, so go for it! It's only a piece of paper!" Her workshops offer an opportunity to meet new friends, try new things and most of all have *fun*!

Two crazy kids and a straight-laced husband keep things interesting in Vicki's home in southern Ontario, Canada.

Follow Vicki on her blog, http://vickiboutin.typepad.com.

Dedication

I am blessed with one on the best mothers in the whole world. She is funny, loving, helpful and encouraging, and she is my very best friend. She has gone above and beyond more times than I can count, and she is so generous with her time and support. I love her more than I could ever possibly put into words. She has made so many things in my life possible, including this book. Thank you, Mom—I love you.

Acknowledgments

First in line, my family . . . Rich, Riley and Devyn. Thank you for your love, your understanding and your patience. This book was a big and wonderful undertaking, and it wouldn't have been possible without your support.

The crew at North Light . . . Thanks so much! Especially Christine Doyle, Kristy Conlin, Christine Polomsky and Megan Richards. You all made this process run so smoothly. Thanks for making me look and sound better than I ever thought possible.

Dad . . . My biggest supporter. Thanks for the early-morning drop-offs, the after-school pick-ups and the all-around awesome help with the kids and whatever else I needed. You are a great father and Boo!

To all my friends, family and paper-crafting pals . . . Thanks. You encouraged me to take on this book, you understood when I needed to "check out" for five months to work on this project, and you have all cheered me on. It helped more than you will ever know.

Huge thanks to the ladies who contributed their gorgeous artwork. It was a pleasure working with you!

Finally, to my dear, sweet and talented cousin Laura Lee. When I was a little girl I thought you were so beautiful and funny and such a talented artist. I wanted people to think I might one day have a gift like yours. I will strive to make you proud and keep you in my heart always.

Resources

The following companies manufacture products featured in this book. Please check your local retailers to find these materials, or go to a company's website for the latest product information. In addition, we have made every attempt to properly credit the items mentioned in this book. We apologize to any company that we have listed incorrectly, and we would appreciate hearing from you.

3M
(888) 364-3577
www.3m.com

7gypsies
(877) 412-7467
www.sevengypsies.com

I'm a gypsy girl at heart

Alex Toys
(800) 666-2539
www.alextoys.com

American Crafts
(801) 226-0747
www.americancrafts.com

Thickers are my fave!

Art Institure Glitter
(877) 909-0805
www.artglitter.com

Great glass glitter!

Avery
(800) 462-8379
www.avery.com

BasicGrey
(801) 544-1116
www.basicgrey.com

Bazzill Basics Paper
(800) 560-1610
http://bazzillbasics.com

Beacon Adhesives
(914) 699-3405
www.beaconadhesives.com

Try their Fabri-Tac glue

Bella Blvd
(414) 259-1800
www.bellablvd.net

Blue Moon Beads
(800) 727-2727
www.creativityinc.
com/bluemoonbeads

BoBunny Press
(801) 771-4010
www.bobunny.com

Canvas Concepts
(800) 869-7220
www.canvasconcepts.com

Canvas Corp.
(866) 376-9961
www.canvascorp.com

Copic
(541) 684-0013
www.copicmarker.com

Clearsnap
(800) 448-4862
www.clearsnap.com

Close to My Heart
(888) 655-6552
www.closetomyheart.com

Coats & Clark
(800) 648-1479
www.coatsandclark.com

Core'dinations
www.coredinations.com

Look for their textured cardstock!

Cosmo Cricket
(800) 852-8810
www.cosmocricket.com

Crate Paper
(801) 798-8996
www.cratepaper.com

Crayola
(800) 272-9652
www.crayola.com

DMC
(973) 589-0606
www.dmc-usa.com

Darcie's
(800) 945-3980
www.darcie.com

Darice
(866) 432-7423
www.darice.com

DecoArt
(800) 367-3047
www.decoart.com

Lots of hidden treasures here

Delta Creative
(800) 423-4135
www.deltacreative.com

Don Mechanic Enterprises, Ltd.
(800) 345-8143
www.donmechanic.com

Doodlebug Design Inc.
(877) 800-9190
www.doodlebug.ws

The candy store of scrapbooking

EK Success
www.eksuccessbrands.com

Elmer's
(614) 985-2600
www.elmers.com

Fancy Pants Designs
(801) 779-3212
www.fancypantsdesigns.com

Fiskars
(866) 348-5661
www2.fiskars.com

Foofala
(800) 727-2727
www.creativityinc.com

GCD Studios
(877) 272-0262
www.gcdstudios.com

Gel-à-Tins
(831) 402-3239
www.gelatinstamps.com

Golden Artist Colors
(800) 959-6543
www.goldenpaints.com

Grafix
(800) 447-2349
www.grafixarts.com

Hampton Art
(800) 981-5169
www.hamptonart.com

Heidi Swapp
(904) 482-0092
www.heidiswapp.com

Hero Arts
(800) 822-4376
www.heroarts.com

Love their stamps

Horizon Group USA
www.horizongroupusa.com

Imaginisce
(801) 908-8111
www.imaginisce.com

In the Making Enterprises
(780) 675-3033
www.morningstarink.com

Glitter galore!

Inkadinkado
www.eksuccessbrands.
com/inkadinkado

Jenni Bowlin
(615) 484-1844
www.jennibowlin.com

Jillibean Soup
(888) 212-1177
www.jillibean-soup.com

JudiKins
(310) 515-1115
www.judikins.com

K&Company
www.eksuccessbrands.
com/kandcompany

Kaisercraft
(888) 684-7147
www.kaisercraft.net

KI Memories
(972) 243-5595
www.kimemories.com

Krylon
(800) 247-3268
www.krylon.com

Little Yellow Bicycle
(860) 286-0244
www.mylyb.com

Making Memories
(800) 286-5263
www.makingmemories.com

Martha Stewart
www.marthastewart.com

Marvy Uchida
(800) 541-5877
www.marvy.com

Great chipboard!

Maya Road
(877) 427-7764
http://mayaroad.com

McGill Inc.
(800) 982-9884
www.mcgillinc.com

Melissa Frances
(484) 248-6080
www.melissafrances.com

Michaels
(800) 642-4235
www.michaels.com

Modge Podge
(800) 842-4197
www.plaidonline.com

My Little Shoebox
(510) 397-8890
www.mylittleshoebox.com

My Mind's Eye
(800) 665-5116
www.mymindseye.com

My Stamp Box
http://mystampbox.com

October Afternoon
(866) 513-5553
www.octoberafternoon.com

Papertrey Ink
www.papertreyink.com

Pellon
(800) 223-5275
www.pellonideas.com

Pink Paislee
(816) 883-8259
www.pinkpaislee.com

Plaid
(800) 842-4197
www.plaidonline.com

Prima Marketing, Inc.
(909) 627-5532
www.primamarketinginc.
com

Provo Craft
(800) 937-7686
www.provocraft.com

My bling supplier

Queen & Co.
(858) 613-7858
www.queenandcompany.com

QuicKutz
(801) 616-5900
www.quickutz.com

Distress Inks are the BEST!

Ranger Industries, Inc.
(732) 389-3535
www.rangerink.com

Sakura
www.sakuraofamerica.com

Sandylion Sticker Designs
(317) 388-1212
www.trendsinternational.com

Sassafras Lass
(801) 269-1331
www.sassafraslass.com

Scenic Route Paper Co.
(801) 653-1319
www.scenicroutepaper.com

Scrapbook Adhesives by 3L
www.scrapbook-adhesives.
com

It's all about the foam squares.

Sharpie
(800) 346-3278
www.sharpie.com

Love this die-cutting machine

Silhouette
(800) 859-8243
www.silhouetteamerica.com

Sizzix
(877) 355-4766
www.sizzix.com

Awesome die for fabric!

Stampers Anonymous
(800) 945-3980
www.stampersanonymous.
com

Stampin' Up!
(800) 782-6787
www.stampinup.com

Stamping Bella
(866) 645-2355
www.stampingbella.com

Stampington & Company
(877) 782-6737
http://stampington.com

Foils for foil transfer

Stix2–KoolTak
(866) 386-8853
www.stix2kooltak.com

Strathmore
www.strathmoreartist.com

Studio Calico
www.studiocalico.com

Great kit club tool

Target
www.target.com

Tattered Angels
(970) 622-9444
www.mytatteredangels.com

TENSeconds Studio
(817) 595-9333
www.tensecondsstudio.com

Metals & more!

The Crafter's Workshop
(877) 272-3837
www.thecraftersworkshop.
com

The Girls' Paperie
(904) 482-0091
www.thegirlspaperie.com

Three Bugs in a Rug
(801) 804-6657
http://3bugsinarug.com

My crafting idol!

Tim Holtz
www.timholtz.com

Tiny Tag Designs
(855) 666-8247
www.tinytagdesigns.com

Tombow
www.tombowusa.com

Tsukineko
(425) 883-7733
www.tsukineko.com

Uni-ball
(800) 323-0749
www.uniball-na.com

Vinnie Pearce
http://vinniepearce.com

You have to check this one out!

Viva Decor
(215) 634-2252
www.viva-decor.us

We R Memory Keepers
(801) 539-5000
www.weronthenet.com

Great tools

Webster's Pages
(800) 543-6104
www.websterspages.com

Westrim Crafts
(800) 727-2727
www.creativityinc.com

Wilton
(800) 794-5866
www.wilton.com

Winsor & Newton
(800) 445-4278
www.winsornewton.com

WorldWin Papers
(888) 843-6455
www.worldwinpapers.com

Home of Glitter Mist

Index

www.fwmedia.com

15 14 13 12 5 4 3 2

DISTRIBUTED IN CANADA BY FRASER DIRECT
100 Armstrong Avenue
Georgetown, ON, Canada L7G 5S4
Tel: (905) 877-4411

DISTRIBUTED IN THE U.K. AND EUROPE BY F&W MEDIA INTERNATIONAL
BRUNEL HOUSE, NEWTON ABBOT, DEVON, TQ12 4PU, ENGLAND
TEL: (+44) 1626 323200, FAX: (+44) 1626 323319
EMAIL: ENQUIRIES@FWMEDIA.COM

DISTRIBUTED IN AUSTRALIA BY CAPRICORN LINK
P.O. Box 704, S. Windsor NSW, 2756 Australia
Tel. (02) 4577-3555

ISBN 9781440311871
SRN X3272

Edited by Kristy Conlin

Cover designed by Steven Peters

Designed by Rob Warnick, Megan Richards

Production coordinated by Greg Nock

Photography by Christine Polomsky

Metric Conversion Chart

To convert	to	multiply by
Inches	Centimeters	2.54
Centimeters	Inches	0.4
Feet	Centimeters	30.5
Centimeters	Feet	0.03
Yards	Meters	0.9
Meters	Yards	1.1

looking for
EVEN MORE INSPIRATION?

Free bonus techniques online!

Oh, the things you can do with the simplest of supplies! In her watermarking technique tutorial, author Vicki Boutin shows you how to make fabulously eye-catching backgrounds with just a little paint, a little water and a little alcohol. You'll be amazed by the results and you'll want to get started right away.

Get this and other **free bonus techniques** (including how to make collograph backgrounds and beaded-dangle embellishments) online at **http://createmixedmedia.com/c-f-bonus**.

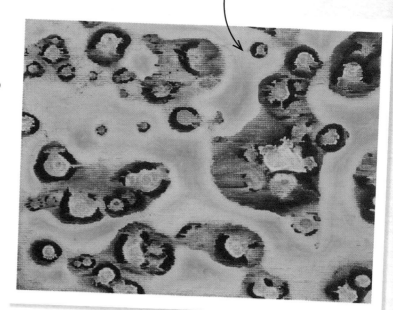

A Great Community to Inspire You Every Day!

CreateMixedMedia.com
ShopMixedMedia.com

For exclusive free projects, tutorials and e-books, blogs, podcasts, reviews, special offers and more!

For inspiration delivered to your inbox, sign up for our free e-mail newsletter.

Or join the fun at:

 facebook.com/CreateMixedMedia.com

 @cMixedMedia

Great techniques and projects from 45 of your favorite North Light authors

Add sparkle, warmth and softness to your craft and scrapbooking projects

These and other fine North Light Craft titles are available at your local craft retailer, bookstore or online supplier, or visit ShopMixedMedia.com.

NORTH LIGHT BOOKS